OSS STATION VICTOR
HURLEY'S
SECRET WAR

PHILIP M. WILLIAMS

AMBERLEY

The importance of communications to secret activities cannot be overstated. It is the efficiency of the communications systems which make rapid intelligence, procurement and dissemination possible.

War Report of the OSS.

First published 2016

Amberley Publishing
The Hill, Stroud
Gloucestershire, GL5 4EP

www.amberley-books.com

British Library Cataloguing in Publication Data.
A catalogue record for this book is available from the British Library.

ISBN 978 1 4456 5428 7 (print)
ISBN 978 1 4456 5429 4 (ebook)

Origination by Amberley Publishing.
Printed in Great Britain.

Contents

Preface

Nearly thirty years ago I discovered that during the Second World War houses and buildings in Hurley were requisitioned by American servicemen, but no one seemd to know why? There were whispers that it was something to do with communications training and then a story involoving US Navy intelligence came to light which added to the intrigue.

It was only by searching the internet many years later that it was my good fortune to discover that Hurley had a wartime code name. By searching the name Station VICTOR I saw some very scant references to an organisation known as the OSS, who, unlike most intelligence services, wrote a war report on all their activities having been disbanded shortly after the war. This allowed me to find a wealth of information kept not in the UK, but across the Atlantic in the US National Archives. Had other local historians known of the name or existence of Station VICTOR before me, then I'm sure they would have been suitably motivated to produce a local history book intending to make the community aware of the important role their village played during the Second World War.

A small local history book can never do full justice to the large range of topics and subject matter involving wartime secret intelligence. I am hoping that those with a local interest will enjoy the photos of wartime Hurley and allow the simple text to guide you and for the more serious reader tell you something new. I hope this book is informative to all readers and encourages others to share in their wartime experiences of Hurley as I am sure there are still interesting secrets and stories to uncover. A point of contact to use is ossstationvictorinfo@gmail.com.

A project of this nature cannot be completed without the support and encouragement of others, especially in the early days. My thanks go to Martyn Cox, Jonathan Clemente, Richard Way and members of the Hurley Historical Group. Special thanks to David Kenney, a veteran of VICTOR, and Dominique Soulier,

author of *The Sussex Plan,* in allowing me to use various photographs from the SUSSEX collection. Thanks to Eric Van Slander and his team at the US National Archives and Records Administration, Maryland, who uncovered many of the official OSS photos and made this publication possible. Also the help, guidance and kind advice from the relatives of the officers and men that served at Hurley, who have been in contact with me. I do hope this book serves them well. I'd like to also thank, for their local assistance, Jeff Griffiths, Ray Brassington, David Brownjohn, John Gray, Doug Hanson and Gavin Pilbeam. Finally I'd like to remember Hurley's late historian and author Mary Howarth, whose character, friendship and knowledge of history gave me the enthusiasm to write this book.

Philip M. Williams
2016

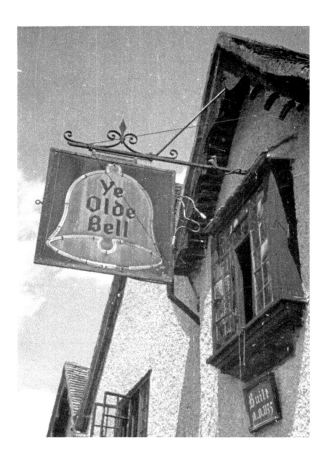

Ye Olde Bell.

Introduction

This book is about a quiet Thameside village in the county of Berkshire and the surprising involvement it had with clandestine activities during the Second World War. Between 1943 and 1945 the ancient village of Hurley became the site of a secret communication station used by the Office of Strategic Services, or OSS. This intelligence-gathering organisation was the forerunner to the post-war Central Intelligence Agency (CIA) and in 1944 it turned Hurley into a communication centre known to its agents by the code name VICTOR. In fact, so secret was Station VICTOR that over the past seventy years it appears to have been somewhat forgotten with little publicised information about its existence and wartime role. It became an essential link between undercover secret agents working in Nazi-occupied Europe and the Supreme Headquarters Allied Expeditionary Force (SHAEF) based in London and its various offices situated throughout the south of England.

For nearly eighteen months of the war, Station VICTOR served as a communications base for many secret operations, such as the SUSSEX plan and Operation PROUST, the aims of which were to obtain vital intelligence by spying on the Nazi war machine. This tactical and strategic intelligence was then collated and assessed, helping to decide which targets the Royal Air Force and US Air Force should attack, allowing a greater degree of accuracy and success. The intelligence sent back by these field agents was to prove vital during the forthcoming battle of Normandy and provided the Allied commanders with reliable intelligence on the locations of SS Panzer Divisions and the German Army order of battle.

VICTOR was generally independent of the British SIS and was the main station for communications for both OSS Secret Intelligence (SI) and X-2 counter-intelligence units, handling their radio traffic en route to the intelligence masters situated in London.

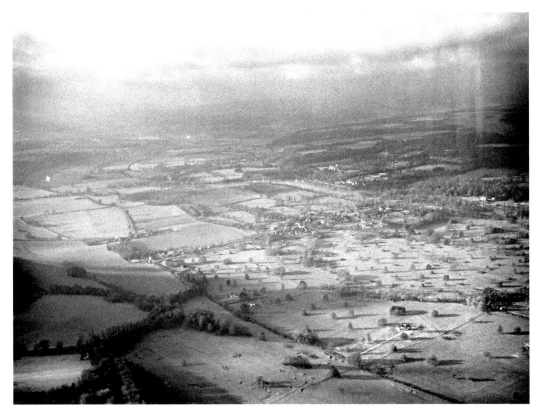

Aerial view of Temple Park looking west towards the village of Hurley (NARA 226-FPL-V-03).

After the liberation of France and the Low Countries, the OSS became the main Allied organisation to fund and coordinate the sending of undercover agents into the German Reich itself. VICTOR then became the communications base for the various teams who were operating as far as Bavaria and Austria where Hitler's diehard Nazis were feared to make their last stand.

At the end of September 1945 the OSS were disbanded and Station VICTOR appears to have closed down. The buildings were abandoned and equipment stripped out, leaving behind the empty transmitting and receiving huts, accommodation and mess huts and the engineering workshops. These buildings then became the responsibility of the General Post Office (GPO), now better known as British Telecom (BT), and over time they have slowly been sold off, blending into the working community of the village. VICTOR quickly became forgotten with many of the OSS personnel never returning. They were shipped back to the States, some continuing their careers in the CIA and never talking about their experiences at Hurley due to their oath of secrecy. Many of the multinational field agents that communicated through Station VICTOR never knew of its real name and location as capture would have compromised

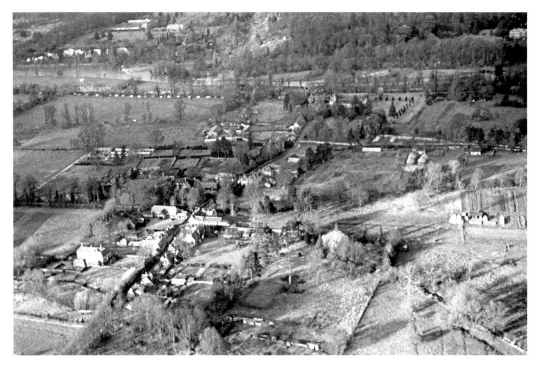

Aerial view of Hurley looking north, taken from a B-24 Liberator *c.* 1944 (NARA 226-FPL-01).

Hurley's importance and risked the area being attacked. All they ever knew was that the radio operator receiving their coded messages was somewhere near to London. VICTOR's operations remained a secret, as if the base never existed.

But it was with some foresight that the activities of the OSS in the European Theatre of Operations (ETO) were to be recorded on the orders of its commanding officer, Gen. W. J. Donovan. Throughout the ETO the OSS maintained daily war diaries which outlined in some detail the operational activities of all of its various branches including Station VICTOR. It is this secret war diary having been declassified and released by the CIA that can be used today as a reference for this publication. This thorough and revealing diary covers the very genesis of VICTOR from its conception and establishment, through to its operational running, up until the later stages of the war. Along with other OSS war diaries and documents covering the OSS Communications London, assisted and compiled under the direction of Lt-Col Joseph F. Lincoln, these documents were copied onto microfilm and released into the public domain. Digital copies of these diaries are kept at the National Archives and Records Administration (NARA) in College Park, Maryland, in the United States and along with other declassified OSS documentation and photographs they have become this book's primary source.

Chapter One

The SIS, OSS and Station VICTOR

On 13 June 1942, by the order of President Franklin D. Roosevelt, Gen. William J. Donovan created the Office of Strategic Services (OSS), so becoming the agency responsible for intelligence gathering and specialist operations for the United States Armed Forces. During July 1940, General Donovan had spent time in London researching the British war effort including how the British Secret Intelligence Service (SIS) was being organised and operated. He discovered that the department known as MI6 concentrated on foreign affairs by gaining intelligence across a broad spectrum of enemy activities and was comprised of different branches, one being the newly formed Special Operations Executive or SOE. Its mission was to conduct espionage, sabotage and reconnaissance across Nazi-occupied Europe having been ordered by Prime Minister Winston Churchill to 'set Europe ablaze'.

There were already several groups of resistance fighters struggling against the Nazi authorities but they needed training, organising and equipping in order for them to be more effective in liberating their homelands. It became a role of the various Allied intelligence services to control and command these different groups ready for the day when the Allied armies crossed the Channel to liberate France and northern Europe. In preparation for this invasion, Great Britain became an island garrison of thousands of servicemen and women – of all nationalities. It was from these ranks of the Free French, Dutch, Belgian, Scandinavian and East European servicemen, along with civilian refugees, that the long process of building a 'Secret Army' commenced. The British Intelligence Service would take the lead over other foreign intelligence agencies fighting this common enemy but now, with America in the war, it was to include the newly formed OSS.

Maj.-Gen. William J. 'Wild Bill' Donovan, Director of Strategic Services (NARA).

Hundreds of volunteers had to be identified, selected and vetted for hazardous duty overseas and many came forward offering their specialist skills such as a second language or military training. Not all were soldiers, many were civilians who had been displaced from their homeland and were eager to return across the Channel to risk their lives to help the Allied cause. Knowing the country, language and area was an important step in reducing the risk and increasing the chance of success of any future missions. At secret locations they underwent training in weapon handling, unarmed tactics, explosives, field craft and counter-interrogation techniques. There was also an operational requirement for secure communications and suitable individuals had to be trained as radio operators proficient in the art of receiving and sending messages in Morse code. These messages were encoded before transmission back to England using small clandestine radio sets often concealed and carried in a suitcase.

Once trained and operationally ready, these field agents were deployed behind enemy lines by parachute using specialist RAF and US Army Air Force squadrons. With the help of the local resistance network a field agent would have to quickly

blend in with the local community, establishing communications with London, identifying safe houses, recruiting volunteers and organising supply drops of arms and ammunition. To set up these circuits meant a great deal of communication to and from London which didn't go unnoticed by the occupying powers. These agents and circuits were ruthlessly hunted down by the Gestapo and Nazi authorities by targeting the radio operators using direction-finding equipment mounted in vehicles and aircraft. Many agents, both men and women, were arrested, tortured and then shot for their clandestine activities. Some were betrayed by double agents and their circuits infiltrated, allowing the Gestapo to send back false information to London and jeopardising the confidence of the whole intelligence network. Whole networks were compromised with dire consequences as fresh agents would be parachuted in, only to be met by the Nazi authorities, leading to their execution. This led to large districts becoming black spots where no reliable information or intelligence would be received by London.

Against this backdrop the OSS set out to work with the British SIS and SOE, establishing their headquarters at Nos 70–72 Grosvenor Street, Mayfair. Six foreign intelligence agencies, in addition to the SIS, were operating in England at the time and London was ideally suited as the OSS base of operations. The OSS had been organised and divided into specialist branches, each covering different aspects of clandestine activity such as Secret Intelligence (SI), Special Operations (SO) and Counter Espionage (X2). These OSS branches, like the SIS, required highly trained individuals being able to operate behind enemy lines along with their British and foreign intelligence colleagues but with the emphasis on supporting the US military side of operations in preparation for the forthcoming invasion of Europe. In order to fill the ranks of these different branches there was an extensive recruitment and selection process within the US Armed Forces. General Donovan defined the ideal OSS candidate as a 'Harvard Ph.D. who can handle himself in a bar fight' and he wanted to recruit the best to lead and innovate the OSS. A vigorous and tough selection process began at secret training locations across the US and Canada that became known by their various code names such as Area C (within the Prince William Forest Park) which specialised in communications training. Area B in the Catoctin Mountain Park (later Camp David the Presidential retreat) was used by both Special Operations recruits and Secret Intelligence (SI) personnel.

During 1942 General Eisenhower became concerned about the French and other resistance circuits being infiltrated by German intelligence, therefore seriously affecting the reliability of the information being passed on. In order to ensure that intelligence could be reliable when the invasion of France occurred, an operation was conceived known the SUSSEX Plan. It involved a tripartite operation between the British, French and Americans services with the Secret Intelligence branch of the OSS leading the American commitment. It was to provide SHAEF with up

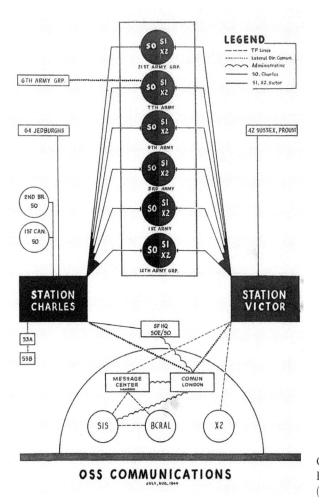

LEGEND
- – – – TP Lines
- ··········· Lateral Dir. Comun.
- ∿∿∿ Administrative
- ——— SO, Charles
- ——— SI, X2, Victor

OSS COMMUNICATIONS
JULY, AUG, 1944

OSS London Communications Branch, July and August 1944 (NARA M1623 Roll 1 Vol 1).

to date tactical and strategic military intelligence by pinpointing enemy troop concentrations and industrial targets. It was thought that as the Allies were establishing their beachheads in Normandy, Hitler's Panzer reserves would be deployed from their inland staging areas against the Allied armies and it was imperative that these threats were identified and stopped as far away from the beachhead as possible. Each day would allow the Allies to disembark further men and material and delaying these Panzer formations would prove critical. By the end of 1943 about three-quarters of SI London staff were devoting the greater part of their time to preparations for SUSSEX that became operational with the parachuting of a pathfinder team into France in February 1944. Under the SUSSEX Plan using two-man teams of an observer and a radio operator, they were tasked to locate enemy troop concentrations and movements in order to send back up to

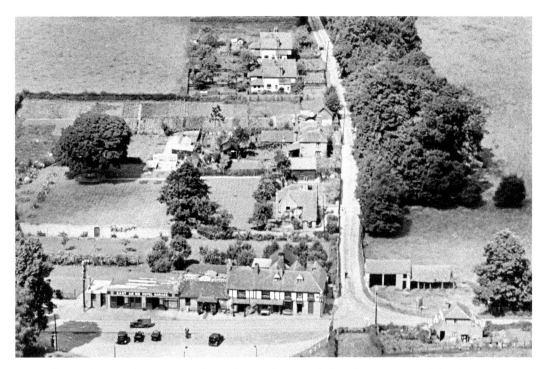

The Henley Road junction with Hurley High Street before being improved by the Ministry of Works (English Heritage EPW036191).

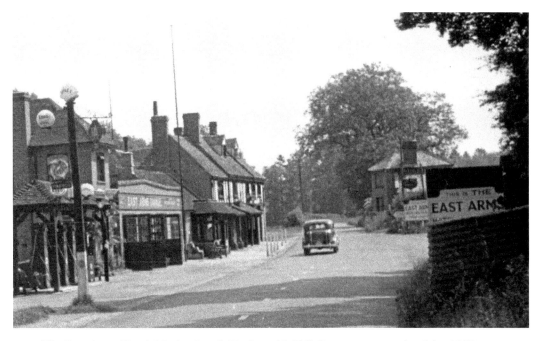

The East Arms Hotel, Henley Road, Hurley with Toll Gate cottage on the right, 1945.

date intelligence which could then be acted upon. SUSSEX eventually became the largest contribution made by the SI branch to the military operations involved in the invasion of the Continent.

It was the prospect of receiving such vital intelligence from these agents that Station VICTOR was constructed as a communications centre. The village of Hurley was to become a radio station transmitting and receiving coded messages

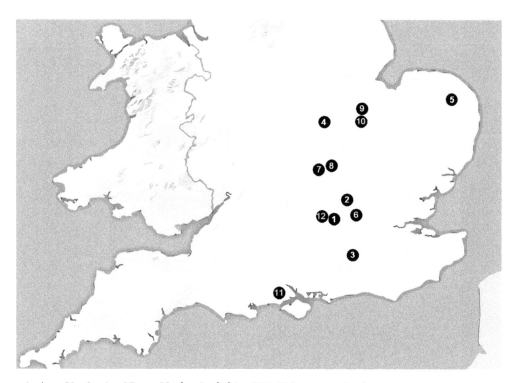

1. Area V – Station Victor, Hurley, Berkshire. SI &X-2 communication centre.
2. Area A – (STS-7) St Albans, 'The SUSSEX School', Glenalmond and Prae Wood House. Operated by SIS and OSS.
3. Area B – 'Freehold' Drungewick Manor, Loxwood, Horsham, West Sussex. SI Training area including PROUST students and SI detachments.
4. Area T – RAF Harrington, Northants AAF Station 179.
5. RAF Watton – AAF Station 376.
6. Area F – Franklin House, Ruislip, London SO Reception area.
7. Area C – (STS-53C) Station CHARLES Poundon, Bucks. Communication Station.
8. Area O – (STS 53) Grendon Hall, Grendon Underwood SI Training (Finishing).
9. Area D – (STS-65) Milton Hall, Milton Park Peterborough, a joint SOE/OSS school including Jedburgh training.
10. Area H – 'Holmewood' SO Air Operations area for packing containers.
11. Area J – (STS-36) Beaulieu, Hampshire. Agent holding and finishing school.
12. Area G – (STS-54a) Fawley Court, Henley on Thames, SOE Jedburgh and SI communication training.

in support of all American SI operations throughout 1944 and then into 1945 when agents started to operate within Germany itself. These messages would be forwarded via secure teleprinter to the message centre in Grosvenor Street where further teleprinter lines connected the various military groups concerned with tactical decision making.

As VICTOR became established it also became the communications base for the OSS counterespionage branch known as X-2. The British insisted that the OSS set up a stand-alone counterespionage unit that could sensitively act on Ultra decrypts coming out of Bletchley Park. In June 1943 X-2 became separated from OSS Secret Intelligence and was given the role of neutralising stay-behind enemy agents and running various double agents back to Berlin.

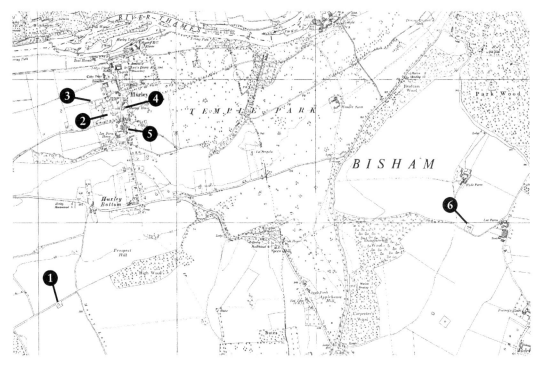

Map of Station VICTOR, Hurley, Berks. 1. Receiving site and Signals Office. 2. Manor House, OSS headquarters. 3. Accommodation huts and motor pool. 4. Hurley House. 5. The Olde Bell Inn. 6. Transmitter site.

Reproduced by permission of www.old-maps.co.uk http://www.old-maps.co.uk SU88 1948 1:25,000 Ordnance Survey on behalf of HMSO. © Crown Copyright. All rights reserved.

Chapter Two
The Establishment of Station VICTOR

There was, however, difficulty in locating a suitable area in which a communications station could be built. It would be ideal that the buildings and facilities required would already be established such as you would find on some large estate. But in 1943, at this stage in the war, with the huge build-up of Allied troops preparing for D-Day, such sites were becoming increasingly scarce. Another problem was that such a facility required a good geographical position that could be used to transmit and receive clean radio signals at ranges of at least 500 miles or more. With this in mind, in early 1943, the Chief of the Communications Branch OSS ETOUSA, Cdr (then Lt-Com.) George L. Graveson set off in a vehicle driving west out of London along the Great West Road. With him he took a radio receiving set so he could stop at suitable-looking places, such as hilltops, in order to check the reception conditions of that area.

Writing in 1982 he recounted that he eventually found a side road (now believed to be Honey Lane) leading to the top of a hill where he found himself in a farm (Hall Place Farm) that was being worked by Italian prisoners of war. He recalled that they respectfully doffed their caps as he was allowed through a gate. He then found himself on a large flat area that had low noise levels and a good reception (the area near High Wood overlooking Hurley Bottom). It appeared that Cdr Graveson had found his site which was set to become the base for Station VICTOR.[1] Not knowing where he was at the time, as all the road signs had been removed in case of invasion, he had to work out his location back at the Grosvenor Street office using old maps and the names of nearby public houses that he recorded along the way, one being the Compleat Angler by Marlow Bridge.

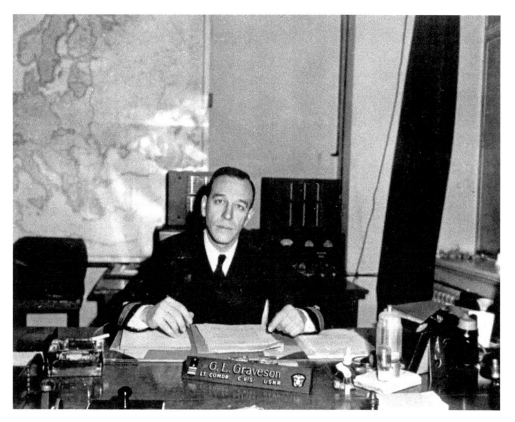

Cdr George L. Graveson, USNR, CO of OSS Communications, European Theatre of Operations (NARA).

The area he had chosen appeared ideal. It was situated on a high ridge overlooking the River Thames and it was decided to place the receiving site (R site) and the main signals control room in an isolated pasture field just to the north of Hall Place Farm. This site was about 100 metres off Honey Lane and had a commanding view above the village of Hurley down in the valley which was able to provide the station with accommodation and administrative facilities. The transmitter site (T site) was to be located two miles to the east along the ridge line on land belonging to Hyde Farm above the neighbouring village of Bisham. Both the R site and T site had sufficient flat adjoining farmland to allow the erection of tall masts to which the antenna wires could then be suspended.

By June 1943 all the arrangements for the occupancy of Hurley had been arranged and construction was due to commence but this had to be delayed. The OSS were already in the process of constructing a radio station at Poundon in Buckinghamshire known as Station CHARLES. This was a much larger joint British and American communication station which was soon to go live with operational

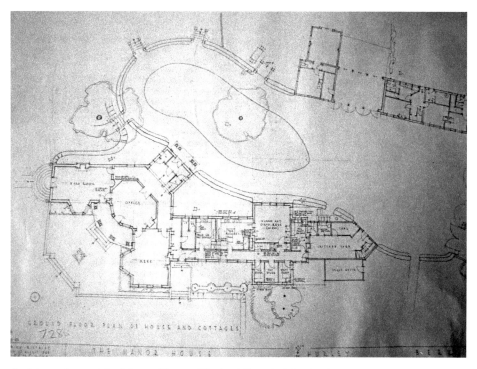

Architect plans of the Manor House (Hurley Historical Society).

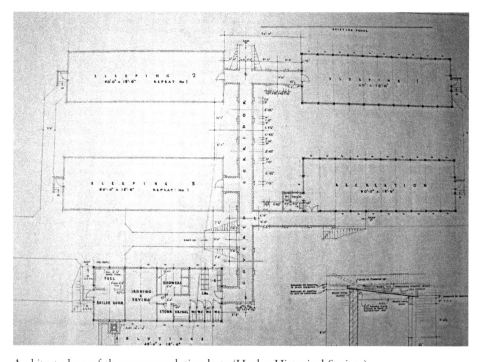

Architect plans of the accommodation huts (Hurley Historical Society).

duties supporting the JEDBURGH and other SOE teams and had to be given priority of any scarce resources.

Plans had been drawn up at the Ministry of Works (MOW) office in Whiteknights Park, Earley, Reading where it was recorded that the Clerk of Works for this project was a Mr Lowell. A headquarters building for the OSS in Hurley had to be identified with suitable rooms for offices, briefing rooms and a mess and with land identified for the construction of barrack style accommodation huts used by the enlisted men. Hurley Manor House on the High Street was deemed suitable and therefore requisitioned by the War Office along with its large gardens and available adjacent farm land belonging to the Burfitt family. Messing and cooking facilities had to be planned along with ablutions and the disposal of sewage for up to 160 personnel. There was also the planning of road access to the various sites, antenna layouts and arrangements made with the General Post Office to furnish and install the necessary intercommunicating cables between the various buildings and to provide secure telephone and teleprinter services to London.

During September 1943 the final construction and alteration plans were approved by the SIS and on 4 October 1943 work got underway to construct Station VICTOR with a target of completion in only two months. But again

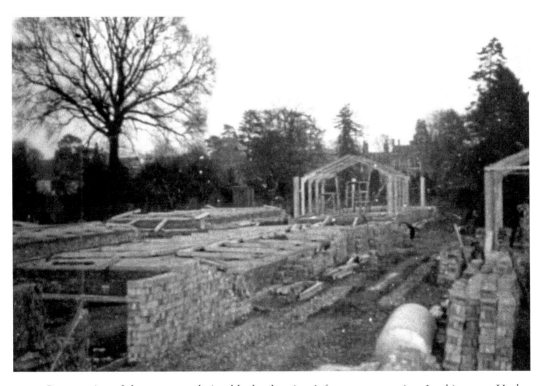

Construction of the accommodation blocks showing A-frame construction. Looking east, Hurley House in the background (NARA RG226).

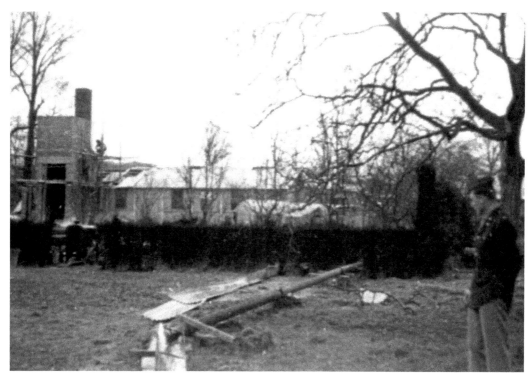

View taken from Manor House garden showing construction of accommodation huts. Lt Herbig in foreground (NARA RG226).

construction work was delayed due to a lack of available MOW and technical personnel and, with only sixty men working on site, this caused the completion date to slip by. During the construction phase snags were identified which added to further delays. There was a complaint that the pitch mastic damp-proof course at the transmitter site was coming away from the concrete and at the receiver site the windows had been poorly fitted. Being exposed on a north-facing hillside during the winter of 1943/44 must have caused the young servicemen a problem and the bad weather had started to wash away the green camouflage paint on the outside of the buildings. The transmitting and receiving sites were given priority to the detriment of the accommodation huts which by January were still only half built. Technical assistance had to be provided by the onsite OSS staff who were made up from the ranks of the US Army Signal Corps and US Navy communication specialists. The sailors would be seen working wearing their issued Navy uniform complete with distinctive white caps, becoming a common sight to the villagers walking down Hurley High Street. Due to secrecy nobody could be told what was going on, security and loose talk were taken very seriously and if anybody ever asked, the servicemen were only involved in training. However, American sailors

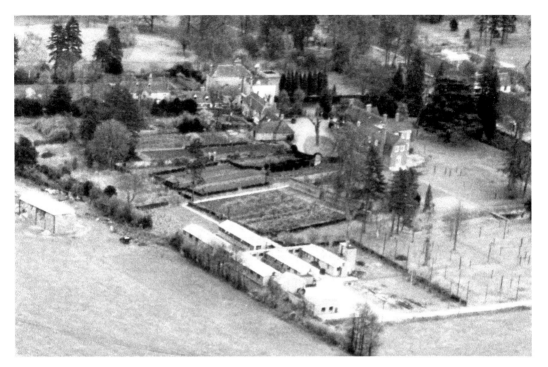

Oblique aerial view taken in 1950 of the OSS barracks and Manor House foreground and centre with Hurley House to the rear. The Olde Bell Inn is top right (English Heritage EAW034256).

working in remote green fields erecting antenna masts ninety miles from the sea would no doubt have raised a few inquisitive eyebrows.

OSS Headquarters, Hurley Manor House

Hurley Manor House was in a suitable position within the village, located just off the High Street and was chosen as the headquarters and officers' mess for the OSS personnel. This modern mansion, enclosed by a much older brick wall and brick-pillared entrance is all that remains of a Tudor-beamed manor house which was pulled down during the First World War. It was requisitioned on 17 February 1943 by the Ministry of War Production (MOWP) to be used by the Land Army and included the 'Kitchens, gardens, access drive and immediate surroundings of 3,000 square feet'. By March 1943 the OSS had earmarked the property for themselves, leaving the Land Army use as a suitable cover. The owner of the property at the time was Basil Mavroleon of Oakley Court, Windsor, cousin to the Kulukundis family of shipping magnates, who received sum of £400 per annum for its use by the government.[2]

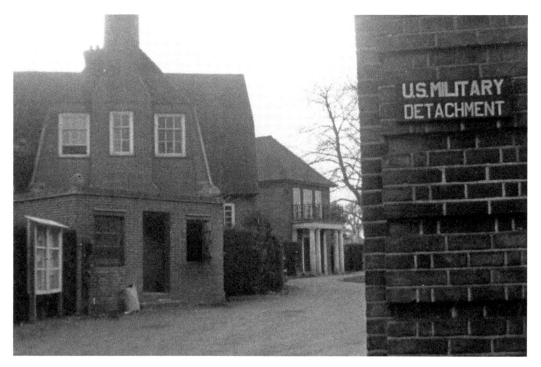

The Manor House entrance, High Street, Hurley. US Detachment sign on brick pillar (courtesy of Joanne Bauguess).

Front entrance to the Manor House headquarters (NARA RG226).

The Ministry of Works drew up plans to modify the heating, sanitation and water systems and they were asked to provide a kitchen space to cater for a hundred personnel. A copy of these plans still exists today and clearly shows the layout of the various offices, ward rooms and accommodation huts that were to be built within the grounds. It was within these grounds with its moat and ornamental gardens that the barracks, consisting of five accommodation huts, were constructed at the northern boundary edge towards the River Thames. Three huts were built for sleeping accommodation, one for a heating and ablutions and one as a recreation hut. All the buildings for VICTOR were built using prefabricated A-frame-style construction which the MOW were providing and erecting at various camps supporting the war effort. A motor pool and maintenance building was built which included a concrete ramp for servicing the various specialist communications vehicles that were to pass through VICTOR in preparation for the Allied invasion. Finally, a concrete access road was laid along the western boundary which led up to the barracks area, the entrance being off Shepherds Lane, now used by Hurley Cricket Club.

To help look after the large gardens and variety of buildings the OSS employed a civilian caretaker called Harold Pilbeam, a veteran of the First World War and holder

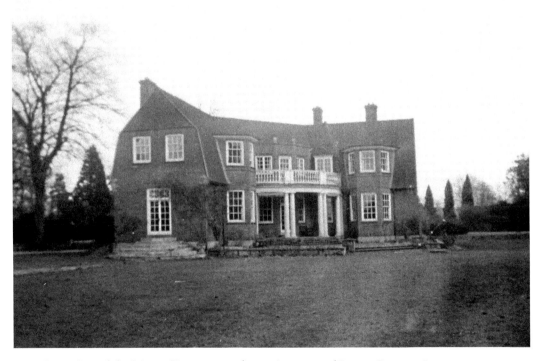

Rear view of the Manor House rear columns (courtesy of Joanne Bauguess).

of the Military Cross. He moved into one of the cottages opposite the Manor House along with his wife and family and it became known as the Caretaker's Cottage.

During October and November 1943 agricultural land belonging to Mr C. J. W. Burfitt was requisitioned in order to install services for the accommodation area, including a sewage treatment works constructed in a field to the west of the village.

By 1 March 1944 the accommodation huts were ready for occupancy, allowing the soldiers, sailors and non-commissioned officers (NCOs) assigned to Station VICTOR to move in. This left the Manor House for officers' accommodation upstairs and a wardroom and personnel office downstairs. The enlisted men's mess was a large downstairs room next to the kitchen and galley area. There was a small officers' guest room upstairs and the OSS were fortunate in that the entrance to the Olde Bell Hotel was on the opposite side of the High Street which was no doubt used for more senior guests.

Even during this construction phase VICTOR's operational remit started to increase and it soon became apparent that obtaining staff to operate both VICTOR and CHARLES was becoming a problem and efforts were made for the US Women Army Corps personnel to help fill the ranks. This in turn led to problems in

View from the south-west. Top, from right to left: officers' quarters, commanding officer's quarters, officer's quarters, servants' wing, small guest room, dispensary, four small rooms for cookhouse personnel. Bottom, from right to left: officers' wardroom, mess room, personnel office, enlisted men's mess, servants' wing, pantry, galley (cookhouse) small mess room, vegetable preparation room, three small rooms for stores (meats, dry goods, vegetables) then through to galley patio, coal room and furnace below (NARA RG226).

Caretaker's cottage looking north (NARA RG226).

planning separate accommodation blocks and a decision had to be made that no servicewomen personnel were to be stationed at Hurley.

Along with the construction of the new sites there was an improvement to some of the access routes and junctions in order to cater for the extra military and construction traffic. Additional access roads constructed of concrete were laid to all of the three sites.

The junction with Hurley High Street and the Henley Road was improved with a new concrete road being laid, and in order to do this the two barns (seen in the 1931 aerial photograph) had to be demolished. This is why today the High Street is no longer straight but deviates towards the Maidenhead direction as you approach the junction from the direction of the village. The two carriageways can be observed side by side at the top of the High Street; the older ancient byway ran along the wall of the now-demolished East Arms Hotel which is in line with the footpath leading up to High Wood. A part of this old road now forms a layby outside the picturesque seventeenth-century house known as 'Traddles'.

Signal Office and Receiver Site (R site), Honey Lane

The buildings requisitioned and built in the village were purely for administration and accommodation purposes. The main operational site and the most important

Top of Hurley High Street looking south towards the toll gate, with the East Arms Hotel to the right, showing the improved junction with Henley Road, 1945 (Author).

area for Station VICTOR was located up on the hill overlooking the village just off Honey Lane and it was here that all of VICTOR's communications were received and transmissions controlled from. A prefabricated concrete and brick T-shaped building was constructed some 126 feet long by 24 feet wide and was of the same standard design as the accommodation huts down in the village. It was a remote spot away from any dwellings and commanded a position that was easily protected with a narrow lane as the only access in and out of the site. Anybody approaching on foot would have to cross open fields and a guard hut was built at the entrance to the site. The land was part of Hall Place Farm, and the tenant farmer Frederick Ridgeway received suitable compensation for giving up good agricultural land.

In the west wing of the building initially twelve small wooden cubicles or booths were constructed where the radio operators could sit. Known as the signals room it measured 36 feet by 24 feet and at each radio operator's position there was connected a Hallicrafters SX-28 Super Skyrider shortwave communications receiver and Morse key. Facing the radio operators across this room was a console desk where the supervising NCO sat. The room was cordoned off by a large glass, soundproofed wall separating the signals room from the main control room

where the operations officer would be placed. Behind the control room there was a machine room in which were a set of teleprinters, and a telephone switchboard which led into an ultra-high frequency (UHF) room. The noise from these machines necessitated the construction of the soundproofed wall to reduce interference to the signals room. Further along the building on the east side was a 24 feet by 24 feet room with a door through to a generator room and boiler room supplying power and central heating with a chimney stack and water tank. From the corridor there was a passageway to the main entrance and an internal guard room which continued on through to two 12 feet by 18 feet offices dividing two toilets and stationary lockers from two other small rooms.

By 15 February 1944 the main power cable had been laid to this building and a transformer had been installed. Relay racks were put up and receivers, speakers and antenna multi-couplers were mounted. Inside the signals room the underground cable was terminated into a coaxial jack panel where it was possible to plug in any of the four antenna multi-couplers which in turn fed into the radio operator receiving positions through rubber-covered coaxial cable.

The shifts or watches for the operators and staff were of only six hours duration in order to reduce the fatigue of having to spend long periods of concentrating on listening to the sometimes faint messages and constant electrical interference. These

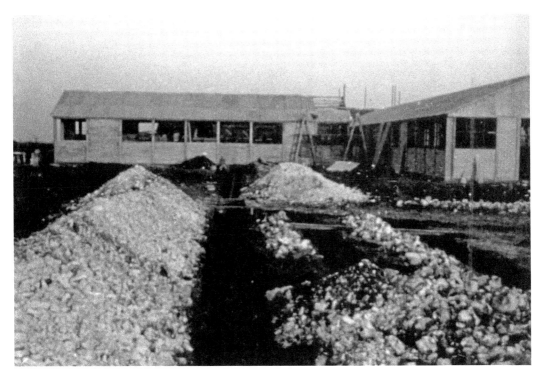

Receiving site off Honey Lane under construction looking west (NARA RG226).

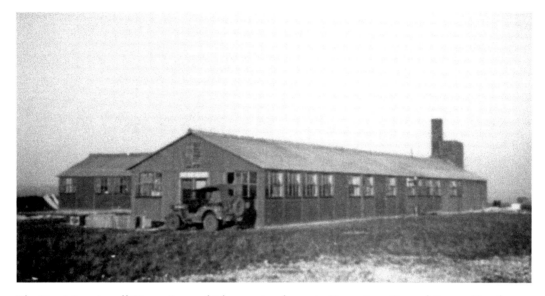

The Receiving site off Honey Lane which contains the main Operations Control Room, Signal Office and Cyper Section painted green, with a jeep in foreground (NARA RG226).

watches had to be maintained twenty-four hours a day, seven days a week until the operational situation dictated a change. The radio operators would sit in their individual booths having been assigned a signal plan which made them responsible for all radio procedure during their contact. Each booth had a frequency meter allowing the operator to ensure perfect tuning to the frequency that he should be monitoring. One of the booths was set aside and equipped and operated as an emergency channel.

The NCO shift supervisor sat between the planning room and the radio operators, maintaining a schedule log. A large blackboard with schedule chart in chalk was hung on the main wall in the planning room which was available for the supervisor to refer to. The operations officer in charge sat behind the glass screen in the control and planning room next to the on-duty planning clerk. He had a vantage point across the radio room with easy access to the machine room with its teleprinters. The planning clerks acted as registrars, logging all incoming and outgoing traffic.

In the field behind the receiving hut were erected eight 105-feet-high Type 32 masts with four three-wire rhombic receiving antenna wires strung between them. Provision was also made that one flat-top antenna be constructed for operational and emergency purposes on a 120-degree-angle shoot. However, it was found that the gain for this was not as great as the rhombic array aerials hanging from the masts. These masts would have been a prominent feature high up on the ridge line and the area later became known as the 'Radar hut' by the local villagers who could only guess as to what the masts were for.

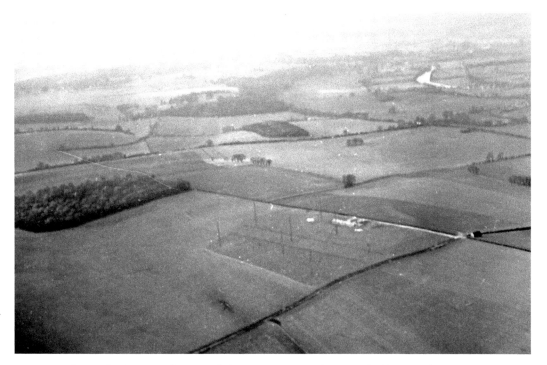

Aerial view looking north west of the receiving site showing the layout of the Type 32 masts, Honey Lane, Hurley (NARA 226-FPL-12).

Transmitter Site (T site) Dungrove Hill Lane, Bisham

For security and technical reasons the transmitting site was constructed two miles away from the receiving site and overlooked the riverside village of Bisham. The transmitter site building and antenna masts were constructed just off Dungrove Hill Lane between Hyde Farm and Lee Farm and all that marks the site today is a post-war metal water tank on a concrete base.

The transmitter site building was built by John Hopkins Builder & Contractor to the same design as the other buildings and consisted of a standard 18 feet 6 inches prefabricated hut some 90 feet long. This contained the transmitters and an operations desk accommodating eight radio-operator positions. There was an entrance way with a toilet leading onto an 18 feet by 18 feet 6 inches shop and a 6 feet by 9 feet tube locker which in turn led to the power room, boiler room and a fuel and power unit. A temporary hut 12 feet by 30 feet was also constructed for housing additional supplies such as antennae rigging and other equipment.

For local communication both the R and T sites were connected together by two 20-core lead-sheathed cables one of which would have been buried underground. Two pairs of cables were used for telephone lines with the remaining eighteen for keying and intercommunication lines. An intercom system was also installed,

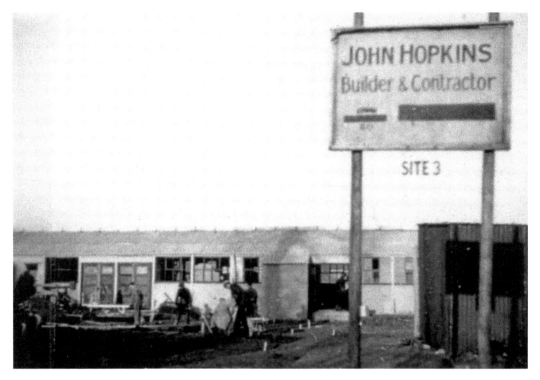

Transmitter site construction off Dungrove Hill Lane, Bisham (NARA RG226).

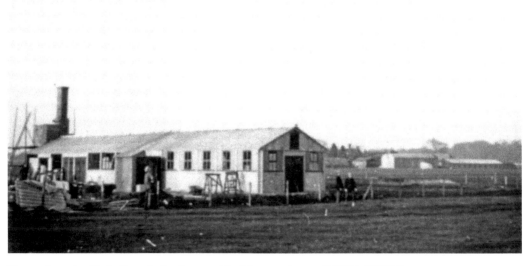

Transmitter site Hyde Farm in background looking north-east (NARA RG226).

linking all the sites. The agreement with the SIS limited Station VICTOR was to only have four 500-watt transmitters but final plans called for the installation of up to twelve. Initially five Canadian RCA AT3 300-watt transmitters arrived in January 1944 and were unpacked and installed without problem. During March 1944 additional construction material arrived and by the end of the month a further four transmitters were installed, another AT3 and three RCA 4332As bringing the total to nine. But when a number of Press Wireless SST-101s were installed it was discovered by one of the technicians Robert Scriven USNR that a vital component had been deliberately cut through with a hacksaw. [3]

It wasn't until July 1944 that T site was complete with fully functioning transmitters and antennae which meant that vital SUSSEX operations during May and June were being conducted with less than ideal equipment. The final transmission masts were at last erected by mid-August 1944, replacing the makeshift poles. The antenna masts were located in the fields behind the hut with five of the transmitters being fed into Marconi antennas. Initially two 70-feet-long 3-inch steel masts were borrowed from the RAF and erected and a span ran between them from which several one-quarter-wave Marconi antennas could be suspended.

Antennae

In order to receive or send a radio signal there has to be some form of antenna which consists of a metal wire suspended above the ground by the use of a mast structure; the higher the wire above the ground increases the range by helping to reduce the interference. At Station CHARLES, completed several months before VICTOR, they were using 105-foot-high steel masts which had depleted all available stocks so that by the end of April 1944 VICTOR was confronted with the prospect of moving into actual operation with too few masts. To get past this difficulty it was agreed that Lieutenant (then Ensign) Norman F. Mennecke USN, a Technical Maintenance Officer, would negotiate with Lady Clayton East of Hall Place, Burchetts Green for some tall larch trees which would be suitable as temporary antenna masts. She was willing to give away any number of trees but was prohibited from doing so by law. To make everything legal a number of trees were purchased for a total of six pounds. Under this agreement the selected trees were marked and cut down by station personnel and then hauled about one and a half miles across country using a vehicle. The poles were sunk 6 feet into the chalk ground, leaving 46 feet above the ground to act as a supporting mast for the wire cable antenna.

Lt Menneke, in surveying the possibility of a flattop receiving antenna at the R site, casually mentioned that if a pole could be erected at the southern end of the building an antennae wire could be strung between the pole and the chimney stack at the other end. Upon returning to the site two hours later, he found that the crew had gone off into the woods and contrary to current law and permissions

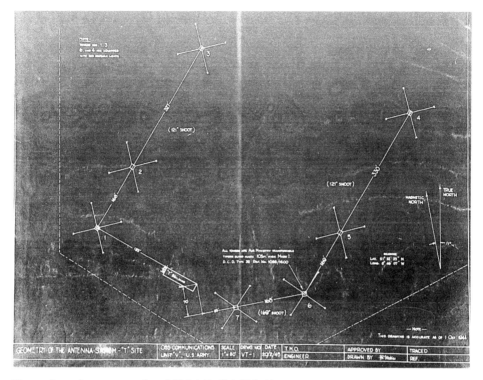

Transmitter site antenna plan (NARA Roll 1 Vol. 3).

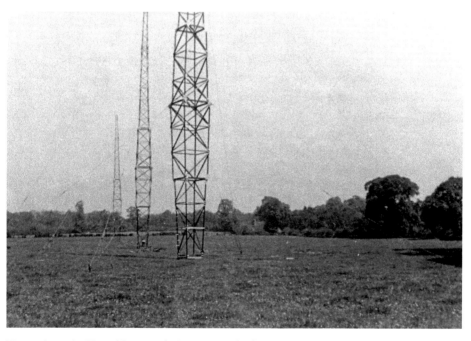

Transmitter site Type 32 masts facing east (NARA RG226).

had enthusiastically taken an axe to a 30-foot tree which they subsequently erected at the south side of the building. This manoeuvre, though, completed a temporary installation enabling VICTOR to move into limited operation.

When the equipment finally became available, the wooden lattice masts that were in service with the Royal Air Force as portable signal masts were issued. This RAF Type 32 mast was a 105-feet-tall wire-guyed structure measuring 3 feet square at the base, spreading 4 feet 6 inches square at a point 36 feet above the ground and tapering off to 2 feet square at the top. It was comprised of six short sections which could be fitted one inside another for ease of transportation on special four-wheeled trailers. Each trailer had a winch fitted at one end which was used to raise and lower the mast once it was removed from the trailer and assembled. Being made mostly of wood they were light in weight and were relatively easy to repair. The mast was mounted on a heavy steel plate which was anchored into the ground using six angle-iron stakes. The guys were attached at all four corners at 36-foot and 90-foot intervals and should have been concreted in but due to a lack of materials iron pickets were used instead.

The allocated frequencies that VICTOR were to operate with were within the high-frequency HF range and would effectively reach Norway and down to North Africa. Therefore the antenna system was to consist of three shoots, 90 degrees for Norway, 125 degrees for France and the Continent and 180 degrees for North Africa which covered the SIS station known as MASSINGHAM.

At the T site the final frequency allocations meant that a total of twenty-three antennas had to be run which required the requisition of more land in order to erect further masts. Negotiations were commenced with the tenant farmer Mr Randall of Hyde Farm through the Ministry of Works. Since this new land was on property that Mr Randall was renting, he was rather reluctant to part with it. In a casual conversation between the landowner, Cdr Graveson and a representative from the SIS, it was mentioned that the best site would actually be on land that cut straight through the fields that belonged to Mr Randall himself. This convinced him that he was better off using the rented land and withdrew his objections. Eventually seven Type 32 masts were raised with three masts covering a total span of 400 feet down the left side of the field on a shoot of 121 degrees and three more covering the same span down the opposite side of the field on the same shoot. From the end of this span the seventh mast was raised on a shoot of 169 degrees. Between these masts were erected the twenty-three delta-matched antennas in two spans at heights of 86 feet and 65 feet. Each mast had a flashing red obstacle light to warn any low-flying aircraft with White Waltham airfield only being about two miles distant.

As well as the antennae, wooden telegraph poles had to be sourced and delivered as fifty were required to carry the twenty-three transmission lines to the transmitter building roof in order to connect the transmitters to the aerials. After

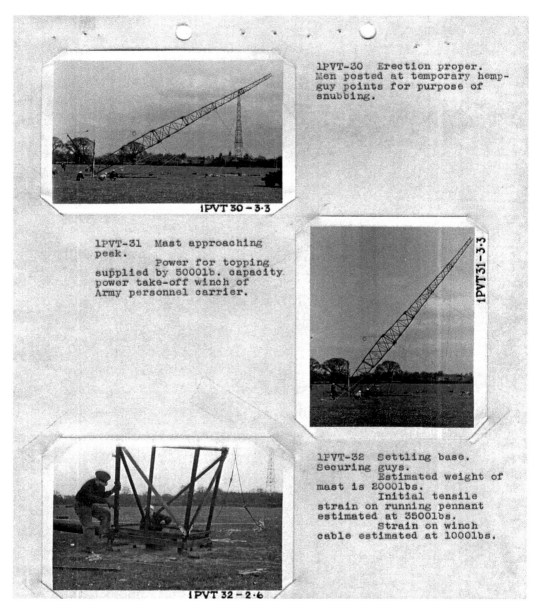

1PVT-30 Erection proper.
Men posted at temporary hemp-
guy points for purpose of
snubbing.

1PVT 30 – 3·3

1PVT-31 Mast approaching
peak.
 Power for topping
supplied by 5000lb. capacity
power take-off winch of
Army personnel carrier.

1PVT31–3·3

1PVT-32 Settling base.
Securing guys.
 Estimated weight of
mast is 2000lbs.
 Initial tensile
strain on running pennant
estimated at 3500lbs.
 Strain on winch
cable estimated at 1000lbs.

1PVT 32 – 2·6

Type 32 masts being erected by OSS US Navy technicians at the Transmitter site, looking east towards Lee Farm, Dungrove Hill Lane, Bisham (NARA RG226).

some delay the poles and the cross arms started to arrive and the station personnel had to dig six footholds through chalk and flint rock to set them in. Transmitter lines were then run to the transmitter building, a total of 29,000 feet of wire being used for the transmission lines alone. For safety reasons the feeders were brought through the roof instead of the wall bulkheads and by 15 July 1944 all wooden temporary masts on both R and T sites had been replaced with permanent ones.

One hazard involved in antennae maintenance was livestock grazing in the antenna fields. At Station CHARLES fences had to be erected to prevent sheep from eating the coaxial lead cables and cattle rubbing against the mast guy lines, loosening them and causing the masts to sway dangerously. VICTOR would have faced a similar hazard and fencing had to be erected which would account for the boundary lines seen on later aerial photographs.

The Technical Supply Depot and Hurley Cottage

The VICTOR diary describes the use of a number of buildings that were required for the storage and maintenance of equipment and refers to the building opposite the Manor House as Hurley Cottage, the quarters for the Pilbeam family. Due to the location inside the OSS compound, it was a perfect location for the caretaker and a security detachment to be billeted but adjoining it was a garage which appears to have been converted into a workshop.

As more technical equipment and stores started to arrive, a technical supply depot and research laboratory were set up in the Manor House grounds, thought to be in this garage. Under the supervision of 1st-Lt Willis E. Boughton (SC) all items of equipment arriving at the station needed to be inspected, tested and any modifications or improvements completed. The process of improvement was ongoing and it fell upon the team to constantly try and improve efficiency and practical application. Initially Lt Broughton had to do this himself as there were insufficient trained personnel to assist him but it was soon discovered that due to the high quality of manufacture and design most of the equipment didn't require many modifications. To overcome the shortage of trained technicians an instruction course of fifty hours over a five-week period had to be organised in order to instruct and train personnel that could cover this task.

One of the main items of equipment stored and checked at Hurley were the field agents' radio sets used to communicate back to their base station either at VICTOR or at Station CHARLES. Earlier in the war British innovation had led the field in the design of small portable radio sets and had managed to develop several types which could be easily concealed in common objects. John Brown, a signals officer, is credited with designing the radios used by the SOE, inventing the so-called 'Biscuit tin' radio and the Type B Mk II suitcase radio.

The OSS had to catch up with this current British technology and with technical assistance from their Allies they developed the SSTR or Strategic Services Transmitter and Receiver series of radio sets. Their portable radio was the SSTR-1 radio set and it was small enough to be concealed in a suitcase and contained one transmitter, one receiver, a power supply and one spare-parts kit along with additional accessories. A 6-volt 20-amp battery provided power but required regular charging using a bicycle or hand generator or, if available, a motor generator. The set of suitcases used to carry all this equipment was still quite heavy and it required an effort to carry it discretely in order to avoid suspicion. Before being issued these sets had to be carefully tested for possible defects and in the case of the SSTR-1 and SSTR-4 certain improvements were made to eliminate what was known as parasitic oscillations. During the early days of Station VICTOR, 2nd-Lt Bruce E. Deahl who was later to become Station Adjutant at Hurley, effected an important change to the SSTR-1 which allowed the operator to tune the radio to a frequency quickly and more efficiently.

Field agents were trained on several different types of radio and were given the choice of which type of radio set they wanted to use. Each set had different characteristics and no one set could be suitable for all circumstances with the range, type of typography and location of the agents and operations being taken into consideration. Nearly half of the SUSSEX teams used the American-supplied SSTR-1 with the other common radio set being the British Mk 7 Transmitter Receiver and the B2 'Jed' set. A substantial number of the SSTR-1 sets were also used for training purposes and issued to the BCRAL French networks and at one stage twenty-five sets were having to be checked and packed at Hurley each day. The total number of sets issued was about 400, the vast majority passing through VICTOR; once these items had been checked they were packed and delivered to areas where the field agents were briefed ready for deployment.

There was also a number of larger more conventional sets that had to be installed in vehicles which were for the OSS SI mobile units travelling with the various Army Group Headquarters. This took up far more space as the vehicle would have to be worked in situ within the depot area. Radio sets such as the SCR-193 were installed into the back of modified jeeps and the larger SCR-399 placed into 2½-ton GMC trucks.

Also within the village was another residence known more traditionally as Hurley Cottage located along the Henley Road opposite Honey Lane which led up the hill to the receiving site. Ideally situated to assist in the operational running of VICTOR, this old cottage contained within its grounds a number of large outhouses that would be suited to storing equipment. Indeed post-war photographs show that one of the garage roofs was covered using similar material as used on other military buildings and the flooring of the outhouses had been heavily damp-proofed with pitch mastic again in a similar way to the accommodation huts. There are no records of this area being requisitioned but its name and similarity to references in the diary indicate its probable wartime use.

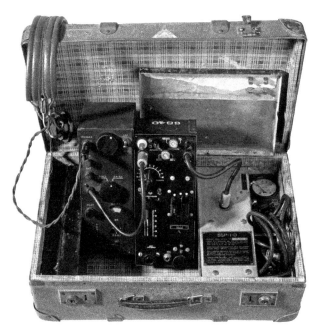

SSTR-1 suitcase radio, the main clandestine radio set used by the OSS (courtesy Ernst Hermann Historica Auctions, Munich, Germany).

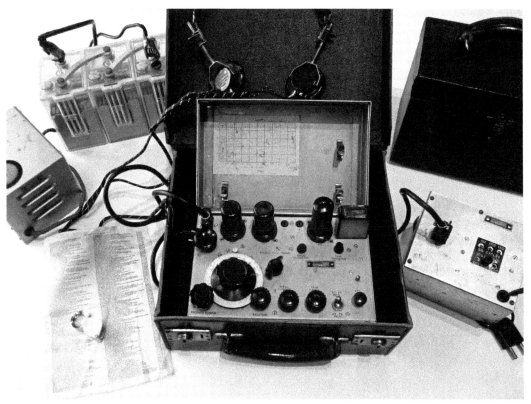

Mark VII Paraset complete with suitcase as used by SUSSEX teams (courtesy Dominique Soulier http://www.plan-sussex-1944.net).

Chapter Three
Operational Matters

The operational side of VICTOR wasn't contained within the village itself but up at the receiving site off Honey Lane. Within this building was the Signals Office where each agent's signal plan was followed and placed in the daily schedule for the radio operators to monitor. For each plan, a radio operator monitoring a specific frequency at a specific time would pick up a Morse code signal sent from an agent somewhere in occupied Europe. As he listened he would write down the strings of five-letter code groups onto a message pad, initially encoded by the agent prior to sending. This message would then be taken to the machine room and teletyped to the message centre in Grosvenor Street. The London centre would decrypt the message and send it to the various Allied Commands as it was expected that the information contained in the message would be of highly operational nature. The machine room at the R site could then receive an encrypted message back from London ready for transmitting back to the agent using the transmitters at the T site. With this operation the machine room was central to the process and therefore created a lot of mechanical noise hence the need for glass screening. Everything that went through the machine room was recorded and filed for reference by the operational duty clerks.

As VICTOR became established a cypher section for the encryption and decryption of messages was set up at the R site in one of the adjoining side rooms. Early plans had made no mention of an encryption or cypher room at VICTOR as all code work was to be completed through the London message centre. But even as VICTOR was being constructed it was realised that its operational function would have to be improved. During the latter part of June and into July 1944, once the Allies were fighting in France, radio traffic greatly increased and it was decided to move a substantial part of the hand cypher department from the London message centre to VICTOR itself.

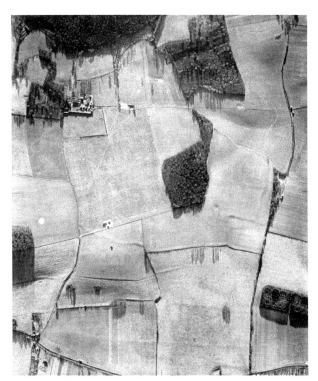

Vertical image of the area between Ashley Hill and Hurley Bottom; the Henley Road is seen running left to right at bottom of photograph. The T-shaped building of the Receiving site is seen left of centre in its isolated position (English Heritage RAF/CPE/UK/1920/13Jan1947).

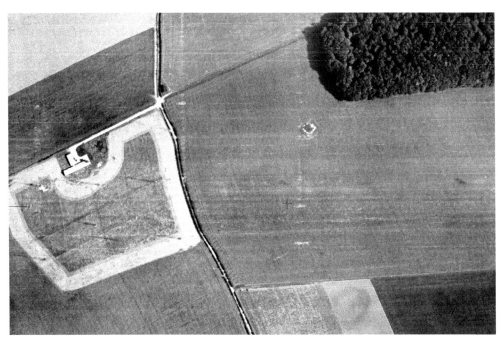

Vertical photograph of the Receiving site showing the T-shaped building area and antennae masts as vertical shadows. Honey Lane runs top to bottom with High Wood to the right (English Heritage RAF/106G/UK/509V5014/13Jul 1945).

This obviously allowed closer cooperation and efficiency within the radio operations. A room 18 feet by 17 ½ feet was allocated at the R site having initially been used as a workshop and renovated to hold five desks. Lt Arthur O. Wurtmann USNR was designated by London to supervise the VICTOR coding department with S/Sgt Colby Cogswell as an assistant. Nine coders working long hours were assigned duties and they were expected to do double shifts several times during the week which meant that even radio operators were drafted in during peak periods.

Maps of the operational areas were set up on the walls allowing the place names to be checked which assisted in the decoding of messages. Sometimes an agent's message would include a minor place name which wasn't obvious to the decoder and this map helped translate garbled or incomplete messages. OSS agents initially coded their messages with a double transposition system where the clear text message was reshuffled twice so it became unrecognisable as a language conveying meaning. The agent would select a specific line from a poem, song or book which would become a base cypher then coded and transmitted as five-letter groups. This system could be difficult to use and prone to messages becoming difficult to

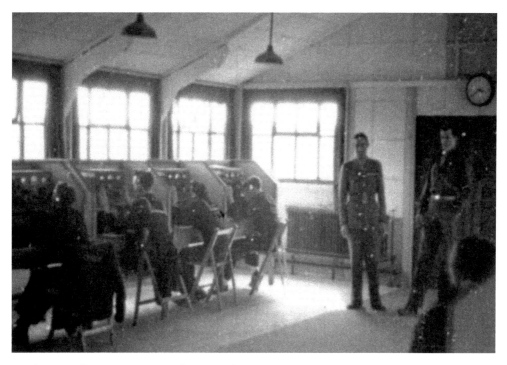

Similar view showing Capt. A. Gillies, British SIS, 1st-Lt William S. Herbig, pre-July 1944 when only twelve receivers were operated within the signals office (NARA M1623 Roll 1 Vol.3).

decode if transmitting and reception conditions were bad. This code system was later replaced with a substitution system known as the one-time pad. The agent was issued with a booklet made up of 100 sheets of nitrate rice paper which could easily be burned, dissolved or eaten. Each sheet was slightly glued on top of the next so that only one page could be used at a time. On each sheet were blocks of five letters printed in random fashion. The letters of the real message would be written under the letters of the one-time pad and the pair of matched letters taken to a table of letters printed on a silk handkerchief issued to the agent. This was used to obtain the cypher letters used in the transmission again sent as five letter groups. At the base station a copy of the same one-time pad was used to help decode the message. The page was then destroyed and the next sheet used for the following occasion when a message was sent by the agent. Due to its success and suitability the one-time pad became the leading cypher for clandestine operations and they came in all shapes and sizes being physically adjusted depending on the demands of the agent. For those agents dropped in Norway and France having to operate on their own in a hostile environment, microphotographs of pads afforded the greatest security. At the base station these pads were supplied as large copies in book form while the one-time pads issued to operational groups such as a Jedburgh teams were waterproofed and made to measure in order to fit securely in a pocket.

Frequency Allocation and Signal Plans

Requests for frequency allotments for OSS operations had to be made to the Wireless Telegraphy Board which also included two ultra high frequency (UHF) links between London and Hurley. The SIS had to allocate these frequencies which were required well in advance so that the necessary crystals could be requested and delivered in order to operate both clandestine and station base radio sets. Because VICTOR was set up rather late during the war the frequency allocation was less than perfect due to overcrowding of the radio spectrum. This led to a lot of interference in the communications between Hurley and its field agents and creating lost contacts, interrupted and garbled messages which were sometimes misinterpreted. A small number of SUSSEX missions were quite critical of 'London' because they were failing to get through.

Initially VICTOR was allowed to set up a simultaneous operation of ten channels. Four of these were allocated to SUSSEX agents, three for normal contacts and broadcasts and the fourth being an emergency channel. An additional four channels were to service the mobile units of both SI and X-2 detachments in the field on a 24-hour basis. The remaining two were for a spare emergency channel and for other operational commitments.

The first contact with a clandestine station working from the continent came in late April 1944. The strength of the signals were QSA 5 (100 per cent readable)

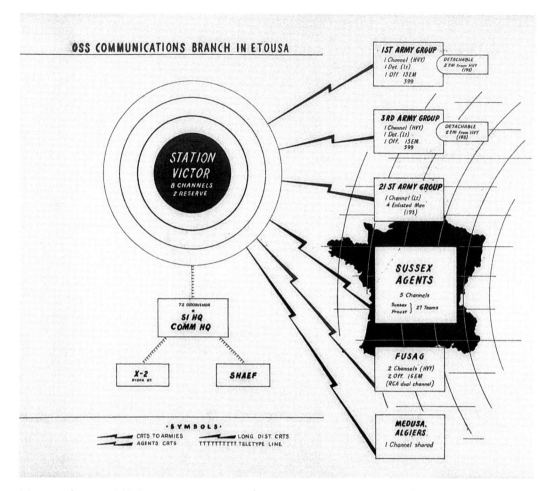

Diagram showing OSS Communications Branch ETOUSA (NARA M1623 Roll 1 Vol. 3).

both ways with the rhombic and half-wave single-wire arrays seeming to work efficiently. When the first operational contacts were being made to help maximise the experience, several operators would monitor the incoming message with one operator handling the key while others would simultaneously record the message. This helped if a message was weak and noisy with other radio interference. Later on messages were recorded so that they could be replayed and checked in order to check any ambiguity.

Before an agent's deployment, a signal plan would be received by the control or planning department at VICTOR which told both base station and agent when to send or receive a signal and on what frequency. It also gave the agent his or her call sign which would change daily in order to confuse the enemy as the Abwehr or Gestapo were constantly trying to locate the position of the agent's transmitters

using radio direction equipment mounted in vehicles and aircraft. Less time on the air meant less time for the Gestapo to locate the agent and the discovery of his network. Accordingly, the agent would only operate to a strict timetable or schedule in order to increase the chance of VICTOR picking up their signal and reducing the risk of intercept. It was policy that the base station never called the field agent on the assumption that the enemy would be listening in, recording the coded messages and if on hearing a base station calling a field agent the enemy authorities could tag an agent as being connected to a particular location or operation.

During 1944 over 140 signal plans of all types (SI operations, mobile units and special missions) were compiled which involved over 100,000 entries by hand, all of which had to be checked. In each case special planning was required dependent on the nature of the mission, the location of planned operations, the type of equipment to be used and the previous training and experience of the operators.

At the base station a log was maintained of the signal plan written in a notebook referring to a particular agent on the inside cover. This notebook was made up of a number of schedule forms and the radio operator, when listening at the time of the schedule, would record the conditions and the nature of the traffic exchanged. At the back of the notebook was a frequency survey chart which would be used to develop a picture of the most satisfactory frequencies to use and, when activated, the plan would appear on the daily master schedule. This list was put out by the planning department and would include the name of the plan and time it would come up plus frequency and the key line to use. The emergency frequency would also be listed. This daily schedule would then be given to the radio room supervisor and to the transmitter supervisor who would allocate the commitment to a particular radio operator. At the R site the radio operator would tune in his receiver and wait for the agent to call while next to him there were separate booths monitoring the emergency frequencies with the daily emergency listings announcing what call signs might come up on the emergency channels.

The series of photographs overleaf illustrates well the internal layout of the Signals Room at the Receiving site. An early photograph taken prior to D-Day shows the radio room laid out with only twelve positions, six on each side of the room. The radio operators are a mix of Army and Navy personnel, overlooked by the duty Signal Officer, Capt. (then 1st-Lt) William S. Herbig (SC) and a British officer called Capt. A. Gillies, Royal Signals, an instructor from SIS communications.

A later set taken on Tuesday 17 October 1944 (as marked in chalk on the blackboard seen in the background) shows the layout with the extra positions having been installed, now twenty-four in total. The time is 1241 hours and the view looks west, the rear door being open, affording a view of one the antenna masts.

At position nineteen sits Cpl Curtis Sturgeon, tuning in his Hallicrafters SX-28 receiver, listening to a faint signal from his contact. His schedule for that day

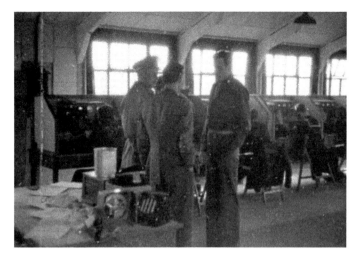

Signals room at the receiving site, with Lt Elmer G. Johnson, Commanding Officer, Capt. A. Gillies, British SIS, 1st-Lt William S. Herbig (NARA M1623 Roll 1 Vol. 3).

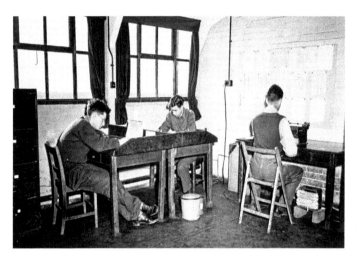

Cypher room set up behind the Signals Office (NARA 226-FPL-14).

Cdr Graveson conducting a hut inspection (NARA M1623 Roll 1 Vol. 2).

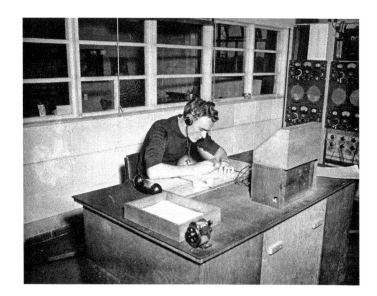

Radioman 2nd Class J. D. Perkins USN, sits at the supervisor's desk in the Signals room, R. site (NARA 226-FPL-06).

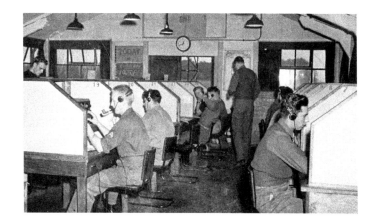

Signals room, R site, October 1944 showing two of the four rows of radio operator positions. 1st-Lt. Herbig is standing in the background, back to camera (NARA 226-FPL-10).

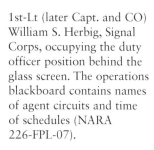

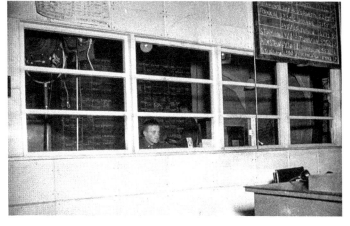

1st-Lt (later Capt. and CO) William S. Herbig, Signal Corps, occupying the duty officer position behind the glass screen. The operations blackboard contains names of agent circuits and time of schedules (NARA 226-FPL-07).

included a contact at 1400 hours with a field operative known as TUNAFISH using a frequency of 5.562 MHz and then KINGFISH at 1500 hours on 5.582 MHz as listed on the operations board. Another photograph shows him looking at the camera, his corporal stripes and Army Air Corps tattoo clearly showing on his left arm.

Sitting in front of the operations board in the glass screened control room out of earshot of the radio operators is the watchful duty officer Lt Herbig. Behind him can be seen the operational blackboard which lists the agent contacts giving the time and radio frequency for each one. Standing in front of this is a clerk whose duty was to update the board from the schedule list he holds in his hand. Listed for contact that day are SUNSHINE (OSS Station at Cherbourg), TUNAFISH, ESPINETTE (Liaison with Belgium Surete), MELANIE (Dutch Resistance), FORCHEVILLE, KINGFISH, JUPIN, SUNNYRIDGE, KING, ORGETA and VELOUR.

From another board written in chalk are the names of other radio operators assisting Cpl Sturgeon including the surnames Miramont, Rankin and Armstrong. Between these operators and the duty officer is a the duty supervisor, Naval Radioman second class J. D. Perkins, who sits at his desk out of earshot of the duty officer, keeping the operation running smoothly between the orders of the duty officer and requirements of the young radio operators. Next to him is a telephone handset used to communicate with the duty officer and a pack of cigarettes.

Training

Due to the use of station personnel helping in the construction of the base, badly needed operational and technical training was delayed which put pressure on the supervising NCOs and officers. Receivers we set up in the manor house and an attempt was made to start radio training whilst building work was being completed.

By the beginning of March 1944 staff could begin to sit down at their operating positions within the transmitter and receiving sites. As the wiring started to be completed, listening watches were posted and the technicians began to concentrate on their proper duties. By April a rigorous training schedule was introduced of at least four hours a day on top of other daily duties. Due to the increasing demands and an insufficient number of operators, Capt. Louis G. Gebhard, Jr US Signals Corp (SC) and Lt Herbig trained an additional eighteen operators who reported to the R site beginning 12 July 1944 for regular tours of duty. It was during this month that work was undertaken to increase the amount of operator positions within the signals room and by the beginning of August a further six positions had been installed. Other forms of training were completed away from VICTOR at Area A (St Albans), Area B (Drungewick Manor, Horsham) and at No. 23 Hans Place which was behind Harrods in Knightsbridge.

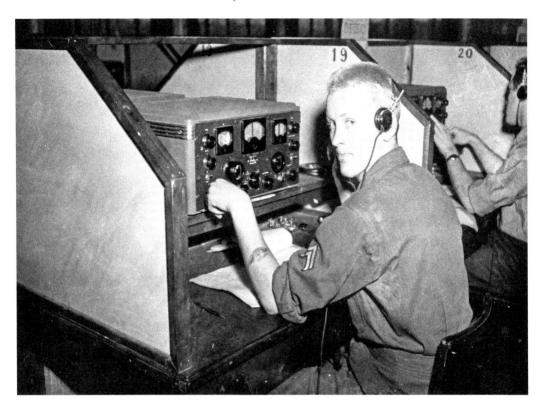

Cpl Curtis Sturgeon, Army Air Corps adjusting the volume on his Hallicrafters SX-28 receiver October, 1944. His right hand is on a Morse key waiting to send (NARA 226-FPL-09).

In the middle of April 1944 Station VICTOR held its first exercise with mobile detachments and it was clear that the radio operators were somewhat rusty with unfamiliar procedure and Morse skills not up to proficient standard and speed. Once VICTOR went operational the skill of the operators greatly improved and as experience was gained the modus operandi and habits of the field agents working from the occupied countries were also acquired.

Chapter Four
The SUSSEX Plan

The Supreme Allied Commander, Gen. Dwight D. Eisenhower, had become concerned about Gestapo and Abwehr counter-intelligence efforts infiltrating and disrupting main resistance networks within Europe. With the approaching invasion the fear of infiltration by double agents and the reliability of the intelligence gathered no longer certain, within the preparation framework for the liberation of France SHAEF conceived and launched a plan entitled Operation SUSSEX.

The idea was that teams of two French officers, an observer and a radio operator working undercover would be parachuted into France where they would provide the Allies with firm information on the deployment of German forces. These teams would covertly observe key junctions, rail heads, bridges and supply routes, sending back vital information on troop movements and their order of battle.

It was to be a tripartite operation as the American OSS and British SIS needed the help of French volunteers to fit inconspicuously into the population of occupied France. They therefore asked the French Intelligence Service, the BCRA, to identify French officers serving within the Allied forces to volunteer for hazardous duties abroad. They were then trained for these missions as part of the SUSSEX plan to provide manpower for the American OSSEX and British BRISSEX teams. One hundred and twenty volunteers from the Free French army, navy and air force were selected and using Area A at Prae Wood House in St Albans as their Headquarters, they received intensive training of between nine and twelve weeks, in military vehicle and aircraft recognition, the principles of observation, tradecraft, map reading, encryption and decryption codes, armed and unarmed combat and parachute training. The successful candidates were then paired up into teams and those selected to work with the OSS (OSSEX) were to use Station VICTOR as their

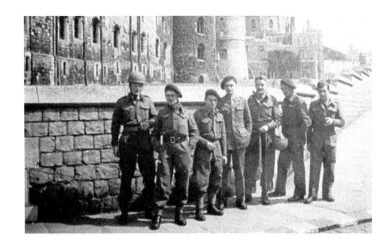

SUSSEX agents having spent a day on motorbike training take a break outside Windsor Castle (courtesy Dominique Soulier http://www.plan-sussex-1944.net).

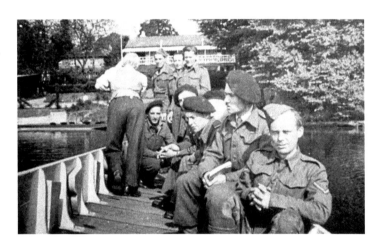

SUSSEX agents during training enjoying a ferry ride across the River Thames at Wargrave, the George & Dragon pub in the background. Facing the camera at the rear of the punt sits Lt George Ducasse aka 'Chaloner' from the CHARLES mission (courtesy Dominique Soulier http://www.plan-sussex-1944.net).

communication base station whilst the SIS (BRISSEX) teams communicated back to STS-53a at Grendon Underwood or STS 53b at Poundon Hall. Field training exercises followed each stage of the training courses.

Some OSS staff from the London office and Station VICTOR were sent to help train the SUSSEX team's radio operators. Lt Gebhard was a communications and field training instructor at Area A. Along with Captain (then 1st-Lt) Robert P. Kennedy Jr (SC) he ensured that the radio operators were proficiently trained in Morse code, radio procedure and technical matters regarding the equipment. They were initially trained to send and receive between seventeen and twenty words a minute and had to be proficient in the use of the different types of clandestine communications equipment. They also had to learn how to code and decode messages using a double transposition cypher and one-time pads. Later in April 1944 Lt Gebhard was posted to Hurley as the Chief Operations Officer where he was responsible for the SUSSEX

briefings and made efforts to build a rapport between radio operators at VICTOR and agents to be dropped into the field.

Portable radio equipment design was very innovative at the time and students had to be proficient in being able to set up, tune in and operate the radio sometimes in the most trying of circumstances. It wasn't a case of pushing a button and talking over a microphone similar to a mobile phone. Technology was still basic and there were many technical difficulties involved in being able to tune into a certain frequency and stabilising a carrier wave which could be heard some 500 miles away. The students were taught how to operate radio sets using the American-made SSTR-1 and the British Mark VII Paraset. Both these sets fitted inside an ordinary-looking suitcase for concealment and could only transmit and receive in Morse code. Due to the nature of rough parachute landings these sets were prone to getting damaged and often required repair using limited spare parts. To cover this students spent a week of technical training at Hans Place in London.

At VICTOR Lt Orwin completed the signal plans for the SUSSEX operations and due to the limitation of frequency channels only a maximum of twenty-seven teams could originally be handled. This was below what was required so in order to increase this, each team instead was restricted to contacting VICTOR every other day which then allowed for forty-six slots of forty-five-minute duration. This increased the number of operational agents from twenty-seven to fifty. If the

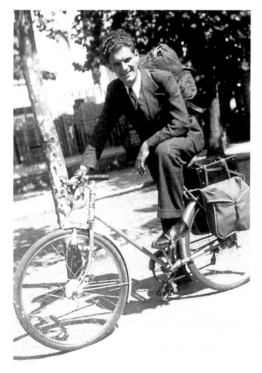

Lt Pomeranz aka 'Piron' from the Madeleine mission on a bicycle somewhere in the vicinity of Vincennes with his Mk VII radio in a suitcase on the rear luggage rack (courtesy Dominique Soulier http://www.plan-sussex-1944.net).

information was really vital the teams could always fall back onto an emergency channel monitored at the receiving site off Honey Lane.

The teams were to be inserted at night time by parachute and 'Pathfinder' teams were dropped in advance of the main SUSSEX agents. The first of the Pathfinders went in during February 1944 and their role was to identify safe houses and contacts which would assist with the future missions. Drop zones were then identified and scouted ready for use.

In order to deliver the agents and supplies to resistance groups, selected RAF and USAF bomber squadrons were trained for the purpose of flying these night-time parachute drops. Stationed at RAF Harrington were the 492nd Bomb Group flying heavily adapted B24 Liberators in support of the OSSEX operations and they were responsible for inserting many of the teams working back to Station VICTOR. These flying crews were known as 'Carpetbaggers' after the name of the operation. The male agents or 'Joes' and the female agents 'Josephines' having been finally briefed and kitted out, would jump through a 'Joe hole' in the floor of the aircraft hoping to meet on the ground a friendly reception committee.

Once the Pathfinder missions were ready the first OSSEX teams parachuted into France during April and May 1944. Their code names were PLAINCHANT, VITRAIL, JEANNE, PLUTARQUE, EVASION and DIANE. Of these six teams that were scheduled to contact VICTOR on the first day five actually made contact with the first intelligence reports being received and deciphered from team JEANNE. This message contained five items of intelligence including map coordinates of two munitions dumps, the location of a German demolition training establishment, a report of forced evacuation of civilians from a village and confirmation that another munitions dump

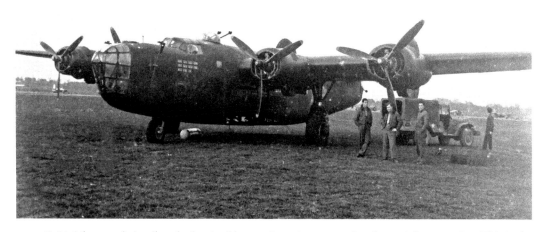

B-24 Liberator being 'bombed up' with containers in preparation for a night operation. This is the operational aircraft used by the 'Carpetbaggers' to drop agents and supplies (NARA Roll 5 Vol. 12).

in a specific location did not exist. JEANNE, located in Orleans, went onto become one of the most successful SUSSEX teams sending over 100 intelligence reports.

Before D-Day on 6 June 1944, intelligence was coming into VICTOR from teams located in the Le Mans, Chartres, Orleans, Tours, Blois, Romilly and Melun areas. These teams were identifying German units, troop movements, fuel and munition dumps and were reporting on the results of the Allied bombing attacks. All these messages via VICTOR were passed back to SHAEF and the various OSS field detachments located with G-2 in each Army Group, with copies also being sent to the SIS and BCRA.

Between 25 May and 8 June 1944 the original six teams accounted for thirty schedules in which fifty-eight messages were exchanged. This covered some 2,500 of the five-letter code groups.

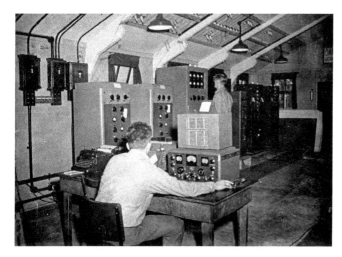

View of the interior of the transmitter building Station VICTOR, showing the large Canadian RCA and Press Wireless transmitter panels. Hallicrafters SX-28 receiver and speaker in front of the duty supervisor (NARA 226-FPL-07).

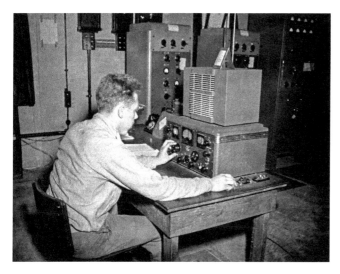

Duty supervisor at the Transmitter site, Hyde Farm, Bisham (NARA 226-FPL-08).

Between 9 June and 22 June 1944 five additional teams were heard and between 23 June and 15 July, eighteen OSSEX teams contacted VICTOR with 100 contacts resulting in 191 messages exchanged which equated to about 10,000 letter groups. As each week passed further teams were inserted which increased the amount of radio traffic VICTOR had to handle. It is thought in total fifty-four SUSSEX teams were deployed over the summer of 1944 comprising twenty-nine OSSEX and twenty-five BRISSEX teams.

The 'VIS' Mission

In order to understand the experiences of SUSSEX agents, and the role that Station VICTOR played, it would be interesting to summarise the memoires of Georges Soulier who was a radio operator with the VIS mission first published in Dominique Soulier's book *The SUSSEX Plan*.

The VIS Mission was an OSSEX team consisting of Lt Henry Jourdet aka 'Henry Waas' as the observer and Lt Georges Soulier aka 'Georges Sautel' as the radio operator. During 1944 both had been trained at Area A in St Albans and, while awaiting deployment, moved to Grendon Hall under the supervision of Capt. Douglas W. Alden of the OSS. They were issued with their equipment and unmarked civilian clothing and given two Mark VII radio transmitters in order to contact VICTOR, one being a spare. They were each given a Colt .45 automatic handgun for personnel protection and a suicide pill containing cyanide in case of capture and torture.

The VIS area of operation was the city of Blois about 150 miles south-east of Normandy and their sector extended to Vendome in the north, Orleans in the east, Tours in the west and Vierzon in the south, all within a sixty-mile radius. They also carried 200,000 francs, a small fortune at the time, which would be required to assist in setting up their intelligence network.

Their contact on the ground was 'Pierre' who was responsible for securing and lighting the drop zone, marking it out for the B24 Liberators of the Carpetbagger Squadron operating out of RAF Harrington. 'Pierre' had been notified by a coded personal message sent by the BBC. These random messages were sent in clear over the airwaves and were commonly used to contact French Resistance groups.

Four teams using two aircraft were to be parachuted in, a dangerous manoeuvre as it would be at night, flying at reduced speed at low level and without the use of navigation lights. Any cloud could obscure the drop zone and would cause a catastrophe and indeed it took three attempts on consecutive nights and a near collision until they were able to safely parachute into France. It wasn't an uncommon occurrence that agents were killed or seriously injured due to entangled parachutes and landings on objects or in water. In order to assist the B-24s of the Carpetbagger Squadron were fitted with 'Rebecca', a transponding radar that picked up signals from 'Eureka' a ground-based transmitter used by the welcoming Resistance team.

Rebecca calculated the range to Eureka based on the timing of the return signals, and its relative position using a highly directional antenna.

Along with teams from the 'Madeleine', 'Marbot' and 'Cure' missions, VIS were parachuted onto the Savennières racetrack west of the city of Angers on the night 1st and 2 June 1944. They spent the remainder of the night locating and recovering their equipment containers and loading them onto a horse and carriage supplied by a local farmer. At the farmyard they were told that they couldn't stay and had to leave by 6.00 a.m. and were given instructions to meet Monsieur Vignon, the Secretary General of the Prefecture of Blois, as their next contact.

Blois was over 130 miles away, a journey fraught with danger having to use false papers. While waiting for a train with their heavy conspicuous bags which included their suitcase radio, the conversation on the platform by the local residents was all about the three nights of low-flying aircraft and what operation might be happening. This hadn't gone unnoticed by the authorities and several days later the silk parachutes were discovered at the farm and the farmer shot for assisting the enemy.

Due to the Allied bombing of the rail network, team VIS didn't arrive in Blois until 5 June and only then were they able to make contact with the Secretary General who gave them a safe house to stay at. This happened to overlook the town's ancient stone bridge across the river Loire and they succeeded in establishing contact with VICTOR the following day. Because the bridge was still intact they were tasked by SHAEF to report on any troop movements crossing the Loire and any military railway activity heading for Normandy battlefront. It was also

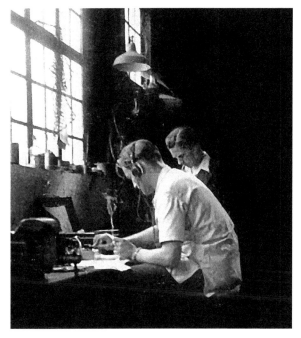

A rare photograph of Lt Brochard and Lart of the 'Drolot' team transmitting a report using a Mk VII 'Paraset' radio from a garage in Amiens (courtesy Dominique Soulier http://www.plan-sussex-1944.net).

fortunate that the manager at the railway station was a friend of M Vignon who passed on information of any troop trains and tank columns which VIS then radioed back to VICTOR. The railway bridge was already badly damaged but had been repaired, allowing German troop reinforcements to cross the river. As soon as information was received by VIS that a troop train was able to cross, VICTOR would be informed and the air force would bomb the target. After the air raid the civil authorities would then be tasked in assessing the damage which fortunately fell to M Vignon who via Lt Soulier and his Mk 7 radio would send the damage report back to Hurley as a coded message.

The Blois road bridge was also being heavily used by German troops and messages were constantly having to be sent back increasing the risk of being detected by the Nazi authorities. Before being discovered, the team's situation suddenly changed as a bombing raid on the bridge hit the building they were using, nearly killing them both. Their quarters were wrecked and they had to evacuate to an alternate safe house 12 kilometres outside of the town to an isolated farm near the village of La Chapelle Vendomoise.

Once contact with VICTOR was re-established Jourdet returned and stayed in Blois, continuing to organise and run a network of contacts, any information going to the farm where Soulier would encode the messages and send them back to Hurley. Patriots happy to inform against the authorities included the chief engineer

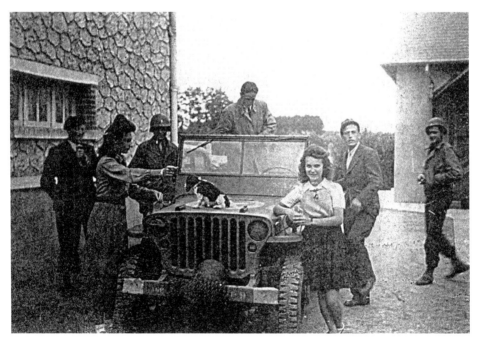

Liberation September 1944. The end of the VIS and FOUDRE missions as Capt. D. Alden, DIP Agent Processing Officer, collects Lt Georges Soulier and Jacques Coulon outside the city of Blois (courtesy Dominique Soulier http://www.plan-sussex-1944.net).

of the Civil Engineering Department and the head of the police force. However, M. Vignon had to leave his post as soon as he became under suspicion but Maurice Fleury who worked for the Prefecture took over his role. Some of the important information obtained and passed to VICTOR during the following weeks identified the location of V1 and V2 rocket-launching sites.

But time and luck was running out as Jourdet came close to being arrested himself and had to leave very quickly after being tipped off by the Chief of Police. This left Lt Soulier to carry on running the network on his own and keeping in contact with VICTOR. Days later during the transmission of a long message the farmer's eleven-year-old daughter saw a German direction-finding van driving slowly down the road near the farm. Soulier managed to escape to safety and luckily the farm was never searched, saving the farmer and his family, but the location had been compromised and another safe house had to be found.

This was a small fishing cottage by the river 10 kilometres from the village of Onzain and Lt Soulier used Maurice Fleury as a runner who was soon bringing back further information to send. This included a large gathering of German vehicles near his house which, having sent the location coordinates back to VICTOR, was bombed by three US Air Force bombers. Luckily M Fleury and family were unhurt. Twenty-five Panzer tanks were also seen in convoy with support vehicles which, once VICTOR was informed, were targeted by the air force, the aftermath being observed by Lt Soulier as he noted the smoking ruins of tanks and vehicles after the successful raid.

But again the situation changed; within two weeks a Luftwaffe radio-locating aircraft was seen above the village and Lt Soulier had to move on, this time into Maurice Fleury's house in Villebarou closer to Blois. It was now August and the American forces were close by; on contacting G2 Intelligence he was asked to continue his work by crossing the Loire. Using his contacts and local knowledge information started to come in from the towns between Blois and Tours which was reported directly to G2. Eventually Capt. Alden arrived by jeep with another agent from St Albans, Jaques Coulon from the FOUDRE mission and Dominque had been truly liberated. By 1 September he was in Paris but his war had yet to finish and he remained on active service.

Constant Danger

Fifteen SUSSEX agents were known to have been killed in action or missing between February and August 1944. Six were OSSEX agents and included the following.

On 10 June 1944 Lt Jacques Voyer aka 'Lucien' of the VITRAIL mission was stopped by two Feldgendarmen (Field Police). He was searched and sketches of tactical vehicle markings were found in his wallet. He tried to escape but was shot twice and captured. For eight days he was tortured but did not speak and on 26 June 1944 he was sentenced to death by military tribunal. He was shot the very next

A post-mission OSS identification card issued to
Lt Georges Soulier (courtesy Dominique Soulier
http://www.plan-sussex-1944.net).

day at the Chavannes shooting range near Chartres. A report by Maj.-Gen. Strong, G-2
SHAEF, summed up the contribution of Team VITRAIL which was representative of
the SUSSEX programme. He stated that the team's identification of the movements of
the Panzer Lehr Division in western France was enough to justify all the work that had
been put into the SUSSEX project even if nothing else had been accomplished.

On 4 July 1944 the three teams of COLERE, SALAUD and FILAN missions were
parachuted just south of Le Mans and were later provided with a stolen military
truck. On 9 August 1944 they were instructed to go to Vendôme but the lorry was
stopped by fleeing German soldiers hoping to get a lift, who were surprised to
see a civilian driver. Having questioned the occupants, they threw off the luggage,
which burst open, revealing a radio set. A further search uncovered weapons and
they were arrested, put back onto the lorry at gunpoint and driven to Vendôme.
During the journey, the agents managed to dispose of some incriminating papers
which were thrown out of the back of the vehicle. One agent, André Rigot, jumped
out and managed to escape, and the remaining five were then handed over to the
Feldgendarmen. A witness later reported seeing Evelyne Clopet, a radio operator
who worked back at VICTOR, unconscious on the floor. Her forehead showed
rifle-butt marks and her thighs had been ripped open by a whip. She had been
tortured for over four hours. In the morning all five agents were put into a cart
and taken to a quarry on the Paris road and shot. None of them had spoken. The
dead agents were Lt Marcel Biscaino, Lt Evelyn Clopet aka 'Chamonet', Lt Aristide
Crocq aka 'Dutal', Lt Roger Fosset aka 'Girad' and Lt André Noel aka 'Ferrière'. A
memorial to their sacrifice is at the Saint Ouen cemetery in the locality of La Croix
Montjoie.

Operation PROUST

Allied High Command were still fearful that too many agents would be captured and decided to expand SUSSEX into a second phase known as Operation PROUST. A further sixty-five volunteers were required some of whom were available from the group of trainees that hadn't been selected for SUSSEX deployment. This operation would increase the number of intelligence teams that could be used post-D-Day and was run solely by the OSS with cooperation from the BCRA. VICTOR would be their base station; between 25 May and 8 June 1944 VICTOR was engaged with training PROUST teams located at Area B at Drungewick Manor known as 'Freehold'. The students would work their messages back to Hurley under the instruction of Lt Kennedy and Lt Gebhard.

On 2 June 1944 the first mission known as GIRAFFE was deployed into Brittany by a Navy motor torpedo boat in the area of Morlaix. Two further teams were inserted in the same manner as not all agents had time to complete parachute training. Other PROUST teams followed, being parachuted across western and central France supporting the rapidly advancing Allied forces, all of whom were using VICTOR as their base station to send back vital intelligence. Not all deployed by parachute; a group of twelve agents in the DRIVER mission were put into the field in order to infiltrate through German lines. They were used as guides, interpreters and assistants within the front line SI units. A total of forty-three PROUST agents were dispatched plus a number of returning SUSSEX agents who, having successfully completed one mission, continued with further missions.

Of these teams there was one fatality: Joseph Jourden aka Jean-Marie Stur who, having been captured and tortured, was executed on 9 August 1944 along with four other Free French fighters.

Chapter Five
Further Commitments

As early as the middle of 1943 OSS HQ in London were looking at a much larger remit for Station VICTOR which would require an expansion of facilities and more staff to help in future operations. OSS Secret Intelligence (SI) informed their communication branch in London that they would need to set up a communications link to each Army Group headquarters for the forthcoming invasion. This was to enable the two-way flow of any real-time intelligence in order for it to be used in tactical planning. This necessitated SI to deploy communication teams to the field which would have to use VICTOR as a base station so extending its original concept. Mobile communication teams and equipment were then assembled at Hurley and the transmitters had to be increased from four to eight in order to cater for this expansion in operations. Area B at Drungewick Manor near Horsham was also used to gather equipment and train personnel and a number of exercises were completed working back to VICTOR.

By August 1944 the US Army in continental Europe included the 1st, 3rd, 9th, 12th and 21st Army Groups. It was the 2½-ton GMC cargo trucks containing SCR-399 radio transmitters and SC-193 radio sets mounted in jeeps that would connect VICTOR with each Army Group headquarters. Radio communications between VICTOR and the field units were excellent as the radio operators of the field detachment had undergone thorough training and used dual-channel receiver–transmitter equipment which was very powerful in comparison with the small transmitters of 5 to 10 watts used by the agents. Communications with these field units were so successful that in emergencies other services in the field tended to use them.

The field detachments acted as an intelligence communications hub for the G-2 or Staff Intelligence Officer attached to the Army Group, sending SI messages to and from Station VICTOR and then onto London. Intelligence was obtained by the use of line crossers or 'Tourists' where OSS field agents, wearing civilian clothing would pass through German lines at night, meeting contacts and returning with their information. Local resistance groups would contact the field detachments asking for weapons and supplies to be dropped ahead of the advancing Allies and other information would be obtained by debriefing front line staff and interrogating prisoners.

These various field detachments were deployed at different times. Known as Special Signal Detachments (SSDs) with the 1st Army Group's SSD-10 being deployed to France on 11 June 1944 with the Third (SSD-11) and Twelfth (SSD-13) following in July.

During August 1944 Capt. Stanley F. Kasper (SC) brought together at Station VICTOR his thirty staff and ten vehicles to be trained and fitted out ready for their attachment to the 9th US Army (SSD-13) which was already operating in northern France. On the 26th they left VICTOR for France landing on Utah beach and established contact within days, operating initially out of Rennes.

X-2 counter-espionage units were also deployed on the Continent using Hurley as a base station. They used and liaised with the field detachments debriefing any SI agents liberated by the advancing Allied armies and protecting any agents that may have been seen as collaborators before the Resistance could shoot them. With their access to Bletchley Park and Ultra they could successfully locate and neutralise stay-behind enemy agents obtaining any relevant intelligence from them including documentation. This complex and dynamic deployment involved a high amount of coordination via messages sent to and from VICTOR, hence they were involved in the training of X-2 detachments prior to them taking to the field. VICTOR had to keep separate X-2 traffic from SI traffic due to its sensitivity and final routing destinations and their traffic was encoded and decoded at a separate message centre in Ryder Street. Later a station known as SUNSHINE was set up near Cherbourg in order to provide a more secure service for X-2 communications.

As expected, immediately after D-Day radio traffic to VICTOR increased at a great rate. The first contact with Allied troops on the beachhead back to VICTOR came at 1700 hours D-Day plus 3 when a signal was flashed by SSD-10 attached to the SO staff of the 1st Army Group. Signals were meant to be received by Station CHARLES but the signal plans and call signs had not been sent out with this detachment, causing a lengthy delay.

On D-Day plus 6, SI handled their first message through a field signal detachment to VICTOR. On D-Day plus 8, the first X-2 operational messages were passed.

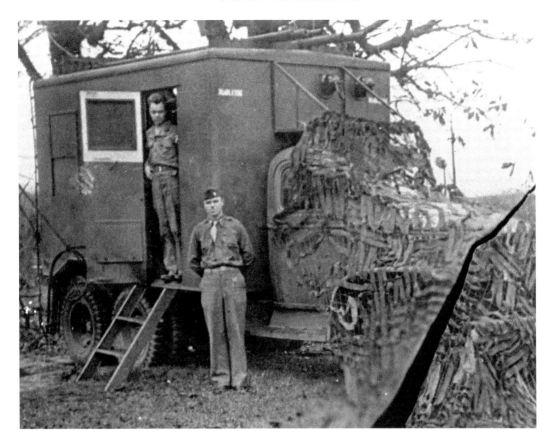

Capt. R. Armstrong and Cpl. Robert L. Kessel, using an SCR-399 radio truck at Station Y, Paris 1944 (NARA M1623 Roll 1 Vol. 4).

Between 9 June and 22 June 1944, the 1st Army SI/X-2 field circuit known as the SSD-1 was established on a 24-hour schedule and 164 messages were exchanged during this period which related to 10,000 five-letter groups being passed through VICTOR.

Between 23 June and 15 July 1944, 355 messages totalling 23,000 groups were exchanged with signal detachments operating for SI and X-2 field units attached to 1st and 3rd Army units.

From 15 July to 1 August 1944 the growth in radio traffic was increasing steadily and the twelve radio operator positions within the receiving site were proving inadequate. This was then doubled to twenty-four once the staff became available.

At this time in the field there were twenty-four SUSSEX teams, four mobile SI detachments and two other missions working back to VICTOR. At times one agent would no sooner finish contacting VICTOR than a second contact would come in. Agents started to use the emergency channel more and more frequently as they had

more messages to send than their allotted time would allow. For the last two weeks in July, 146 contacts with SUSSEX and PROUST teams yielded 166 incoming messages. Added to the fifty-eight outgoing broadcasts total agent traffic for the period was 224 messages accounting for 11,200 code groups.

Operational circuits working to the 1st Army, 3rd Army, 12th Army Group and 21st Army Group accounted for 832 messages exchanged (of which about 300 were training) totalling just under 55,000 groups. By the end of July VICTOR was handling in excess of 30,000 groups a week compared with 10,000 groups at the beginning of the month. It was during this month that a substantial part of the coding and decoding of messages was moved to the cipher room at the receiving site.

According to these figures VICTOR was handling only 14 per cent less traffic than its bigger sister Station CHARLES located at Poundon but with 52 per cent fewer personnel and 76 per cent less channels. To deal with these commitments VICTOR had available only 116 Officers and men which included twenty-four operators overseen by eight supervisors and one operations officer. The staffing situation was described as tight and many men had to work extra shifts in order to cover the schedules which included the chief operations officer completing a regular watch allowing the duty signals officer to work a circuit in the receiving room. During July 1944 there was a consideration to transfer personnel across from CHARLES but in August extra personnel arrived from the States aboard SS *Uruguay* and VICTOR was given the extra staff it required.

Initially Station VICTOR was allocated five officers and forty enlisted men along with maintenance and engineering staff of three officers and four enlisted men. This was based on the original limited scope of commitment but as this changed VICTOR personnel increased, peaking in January 1945 when there was a total of seven officers and 142 enlisted men. Once into the first two weeks of August when VICTOR had a full complement of personnel and operating equipment, it was able to handle 70,000 five-letter groups without any difficulty which equated to over 1,000 messages.

Hurley House and The Mill House

To accommodate this influx of new staff double-tier bunks were installed in the three accommodation huts and additional quarters had to be found. Directly opposite the Manor HQ was an eighteenth-century building known as Hurley House, owned since 1924 by a solicitor called Harold Maison Farrer. Its property boundary extended north to Mill Lane and encompassed some of the fields to the east; it was quickly requisitioned for use by the OSS and included two cottages with several outbuildings. The Ministry of Works then installed extra baths and showers to help accommodate the thirty to forty new staff.

Having been newly shipped in, eighteen-year-old radio operator Private David Kenney from Wyoming was allocated the bedroom immediately above the front door which he shared with two other roommates, his window looking out across the well laid-out garden and down the main path. These new residents of Hurley House had been fortunate; rather than being stuck in the austere accommodation and recreation huts at the main camp they were able to enjoy the comforts and character of the house. Downstairs there was a comfortable lounge which contained a sofa, easy chairs, a radio and plenty of reading material. Pte Kenney spent all of his three months stationed in Hurley working as a radio operator up at the R site between midnight and six o'clock in the morning. Having time off during the day allowed him to cycle and explore the peaceful countryside before he was reassigned in November back to the States and onwards to a more dramatic posting in China.

Another requisitioned building was the Mill House next to Hurley lock, occupied by the boat builder Bob Freebody, his wife Vi and their ten-year-old son Peter. They were told that their house needed to be used as a 'Blanket store' but the word 'Officers' seen today painted on top of a bathroom door seems to suggest a different function. The family had to leave and live five miles away in Woodley with Bob commuting by bicycle to Caversham each day in order to carry on war work for the Admiralty at the family boatyard. On occasions the family would return to Hurley at weekends where they were given two bicycles from the American servicemen stationed in the village.

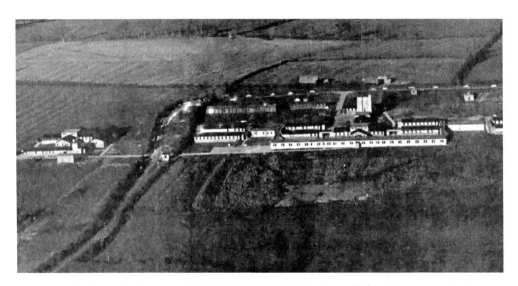

Aerial photo of the joint OSS/SOE Station CHARLES used for SO communications at Poundon, Buckinghamshire. 'VICTOR's big sister'. The receiving site is left of the road, the remainder of the buildings are administration. The transmitter site was located two miles away at Twyford, Bucks (NARA RG226).

It is likely that other village buildings would have been requisitioned but not all the records survived. Lee Farm off the High Street was known to have military tenants staying there along with a Special Constable from London, William Langdon. These guests were seen to travel daily by foot or bicycle to Bisham Abbey in order to carry out their wartime work.

Due to the secret nature of the area, the station had a security section comprised of an officer and fourteen enlisted men who would work shifts manning the sentry posts at each site. A small brick-built shelter that existed opposite the cricket club off Shepherds Lane guarded the concrete-laid approach road to the accommodation and motor pool areas. A similar shelter protected the entrance off Honey Lane to the main signals office and receiving site with a guard room within the site itself. The guards could drive between the R and T sites along a concrete road off Honey Lane and past Hall Place. At the time this large building housed the headquarters of a Home Guard detachment, known as Hurley Company, 2nd Berkshire (Maidenhead) Battalion.

Ye Olde Bell

A stone's throw from the Manor House and the OSS Headquarters stands an ancient hostelry known as Ye Olde Bell Inn which since AD 1135 has been a guest house for visitors to Hurley's Benedictine priory. In 1935 this famous hotel was bought by Giulio Trapani, an Italian who came to England as a boy, his father being in the high-class hotel business having worked for some years at the Ritz in Piccadilly. At the outbreak of war, due to his nationality, Trapani was classified as an enemy alien which didn't seem to deter him as he continued to run a successful hotel business throughout the war years. He even did his bit by volunteering as an auxiliary fireman and was often seen serving drinks at the bar wearing his fireman's uniform and cap.

In 1938 he bought from the Burfitts, the barns and farmyard once belonging to Lee Farm that are now seen around the hotel's car park. Earlier in the war, when arms production was dispersed from the Midlands, these barns where turned into a small arms factory, producing ammunition by using the local Hurley ladies as a workforce.

With the arrival of the OSS a business opportunity arose and Trapani created an American bar within the hotel. This became the domain of the commissioned officers and distinguished guests where a uniformed doorman would stand guard to keep the young enlisted men away. This mini club became a meeting place for OSS officers and secret service personnel where many interesting conversations could be overheard. Mr Trapani once congratulated Col Elliot Roosevelt (son of President Franklin D. Roosevelt) on his recent promotion to brigadier-general which came as a surprise as he didn't know

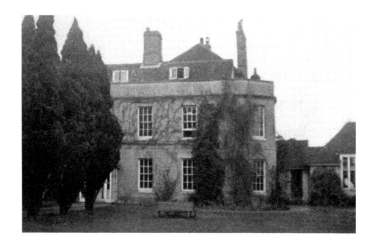

Hurley House
in 1944 used as
additional billets
(courtesy of Joanne
Bauguess).

Inside view of the
recreation hut within
the accommodation
area, now used as the
Hurley regatta store
(NARA M1623 Roll
1 Vol. 3).

anything about it, the official notice having not yet reached him. No doubt Trapani had overheard an earlier confidential conversation and had jumped the gun with his congratulations.[1]

The American bar theme must have become quite popular as photographs taken shortly after the war show this being advertised in large black signwriting on the wall of The Olde Bell. Trapani later went on to purchase the Skindles Hotel next to the Thames at Maidenhead Bridge which included its own American bar during the 1960s.

It was during the autumn of 1944 that the Supreme Allied Commander, Gen. Dwight D. Eisenhower was seen visiting Hurley staying at The Olde Bell Hotel. His large olive-drab-painted staff car with its sign of four white stars on a red background would be seen parked outside on the High Street. But it wasn't

Standing on right. Pte 1st Class John R. Johnson, US Army, a member of the Security Section. (Courtesy of Joanne Bauguess.)

the general that got all the attention; it appears that the servicemen were more interested in seeing his driver Kay Summersby than the general himself.[2] Lt Summersby served throughout the war as Eisenhower's chauffeur and then later as his secretary until late in 1945 when the General returned to the US.

For some period of time General Eisenhower's signature could be seen on the blackboard in the hotel's hallway next to the signature of PM Winston Churchill; unfortunately who they saw and what they discussed while in residence has never been revealed.

Bombing Raid

In her book *OSS: Stories That Can Now Be Told*, Dorothy Ringlesbach mentions a number of incidents that occurred involving the American service personnel stationed at Hurley. One is in relation to J. D. Perkins, a Navy radio operator who during early 1944 was quartered on the second floor of the Manor House prior to the accommodation blocks being completed. Here he would have been in the unusual situation of sharing the building with commissioned officers. He recounted that one evening at around 9 or 10 o'clock a bombing raid took place over a local town, the explosions and lights attracting him and his fellow enlisted men up onto the roof via the attic. On coming down, one of his friends lost his footing and they both fell through the ceiling, ending up in an officer's bedroom who, no doubt along with everyone else, thought the building had been hit by a bomb. Most people ended up under their beds until they realised what the cause of the commotion was all about. It's not recorded what punishment they received but they did have to repair the hole left in the ceiling.

Local history records a German night-bomber raid that occurred over the Maidenhead/Bray area overnight into 23 February 1944 which comprised 155 bombers targeting West London. It is thought that due to heavy anti-aircraft fire and an attack by RAF Mosquito night fighters, the formation of enemy

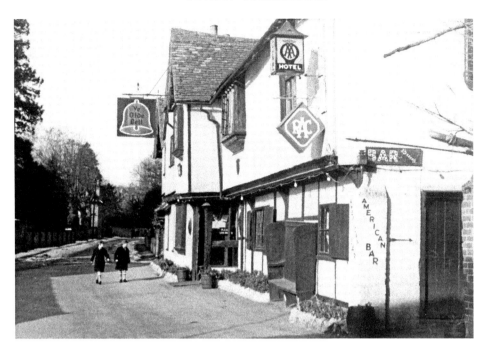

The Olde Bell Inn, Hurley High Street, 1945 advertising the American Bar.

bombers broke up with some having to fly over Maidenhead and release their bombs. Some were recorded falling behind the Bray Police Station on the Windsor Road just outside Maidenhead, causing casualties to US servicemen billeted in a nearby tented camp. One of these German bombers was shot down by the 564th Heavy Anti-Aircraft battery stationed on Dorney Common who managed to expend forty-two rounds during the engagement.[3] It must have been all this activity of searchlights, explosions and crashing aircraft that brought the onlookers onto the roof of the Manor House.

A Tragedy and Near Miss

At 05.20 a.m. on 18 July 1944 only 500 metres south-west of the OSS transmitter building at Hyde Farm, an RAF Halifax bomber en route to attack enemy positions outside Caen in Normandy crashed into Carpenters Wood outside the village of Burchetts Green.

The aircraft, from 578 Squadron based in Burn, North Yorkshire, had been carrying 4 tons of high explosive and 8,000 litres of fuel and caused a massive explosion which damaged local houses and set fields on fire. This large four-engine bomber, while flying over the River Thames, got into difficulties when the starboard inner engine caught fire and the pilot, Flying Officer Victor

Starkoff DFC, lost height trying to avoid built-up areas. The aircraft suffered a mid-air explosion causing the rear gunner to be blown out, who was able to parachute to safety. The aircraft now out of control dived vertically into the woods killing all six remaining crew members and leaving a crater some 100 feet wide.[4]

No mention of this tragic incident is mentioned in VICTOR's diary or any comment to the damage caused to the transmitter site and the tall antenna masts, but by being so close to the transmitters, the enormous shock wave could have had a catastrophic effect on communications at a vital time in the battle of Normandy. On inspection of the crash site, where today a memorial marks the event, a large crater can be seen just below the north–south ridgeline which would have had the fortunate effect of deflecting the blast upwards and away from the masts and buildings housing the transmitters.

Two miles to the south-west along the same ridge line at the receiving site above Hurley, radio operator Pte Julian Kane mentions in his memoirs that early one morning just as he and his colleagues were finishing a night shift 'a never-to-be-forgotten blinding flash was seen which rivalled the rising sun' followed shortly after by a thunderous explosion. When Pte Dave Kenney arrived at Hurley in August '44 he was told about the near miss and that he should have been here the previous week as a 'V1 flying bomb nearly hit the station'. What they thought was a V1 exploding that July morning may have been the impact of the stricken Halifax bomber.

Change of Role and Personnel, Autumn 1944

Between 15 August and 1 September 1944 VICTOR dealt with a traffic load that exceeded 100,000 message groups from thirty-seven SUSSEX and PROUST teams who made 200 contacts netting 216 incoming messages, the remainder being made up from SI units. Each week the Allies were now advancing through France causing agents to be overrun and 'liberated', therefore reducing the amount of traffic going back to Hurley.

Once Paris had been liberated, a new OSS communications station was set up in the western suburbs at Garches known by its codename as 'YONDER' or Station Y.

VICTOR personnel were put on standby to cross the Channel and assist in staffing and operating this new station including Pte Kenney who was tasked with driving one of the jeeps in the convoy. Soon Station Y traffic started to come through to Hurley which was passed on to London, in effect turning VICTOR into a relay station. Paris was using a Hagelin cypher machine (known as Betty) and VICTOR's purpose was to recognise this Betty traffic and relay it on using dedicated radio operators who started working this busy channel. This relay procedure became known as 'Poker' and VICTOR's role

became more administrative in nature than communicating with front line agents. To help handle the routing of normal London–Paris traffic the planning room maintained two registers, coloured red and black, each subdivided into 'In' and 'Out'. The black register was used to keep track of SI traffic whilst the red register was used to keep track of the X-2 counter-intelligence traffic which was on the increase.

Operation JEDBURGH had been a great success and on completion Station CHARLES (STS 53c) could be closed down with the OSS handing the station back to the British SIS. This allowed over 100 radio operators and technicians to become available for reassignment. As the war was far from over, valuable experience was required elsewhere and OSS personnel were sent across the channel to Station Y in Paris while others were sent to the Mediterranean theatre of war, North Africa or further afield to Burma and China. During October 1944 VICTOR underwent a restructuring exercise with the absorption of Station CHARLES personnel including some officers having to leave on promotion. Lt Herbig was promoted to captain on 1 December 1944 and became the Commanding Officer with newly promoted 1st-Lt Deahl as Station Adjutant.

During this period of change VICTOR was kept operational and the new replacements were quickly required to get use to the different plans and procedures and some training was necessary. It was also during October that VICTOR experienced its greatest traffic peak. The station handled 2,802 messages totalling in excess of 235,000 code groups. Of this total 2,324 messages were between VICTOR and Station Y showing that the majority of traffic was now in a relay capacity.

With the closure of Station CHARLES a great deal of extra equipment became available enabling the upgrading and replacement of certain items. At the R site twelve type HRO receivers were installed in the operating bays with an RCA AR88 placed in bay 7. Each receiver had attached to it an individual electrical ground which succeeded in lowering the noise level experienced by the operator. In the machine room a teletype scrambler or SIGTOT machine was installed for secure communications to and from the London message centre.

Nine type 4332A and one press wireless type SSTR-101 transmitters were installed at the T site and all the older transmitters were removed for storage. An extra RCA multi-coupler was installed and the AC to DC converters were upgraded.

By the middle of November a secure teletype line was completed between the London and Paris message centres which caused a massive decrease in VICTOR traffic. By the end of November all SUSSEX plans were cancelled and any remaining mission plans were switched to Station Y. It was becoming clear that Paris was to be the main OSS communications base handling SI and SO contacts and VICTOR with its decrease in traffic had to find a new role.

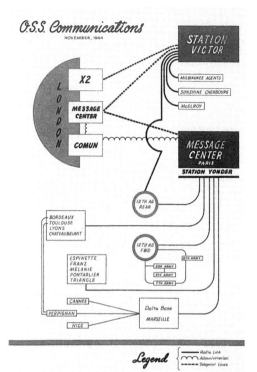

Diagram showing OSS Communications, November 1944 (NARA M1623 Roll 1 Vol. 1).

1st-Lt. Bruce. E. Deahl, 1945, Adjutant, Station VICTOR (Bruce Deahl collection).

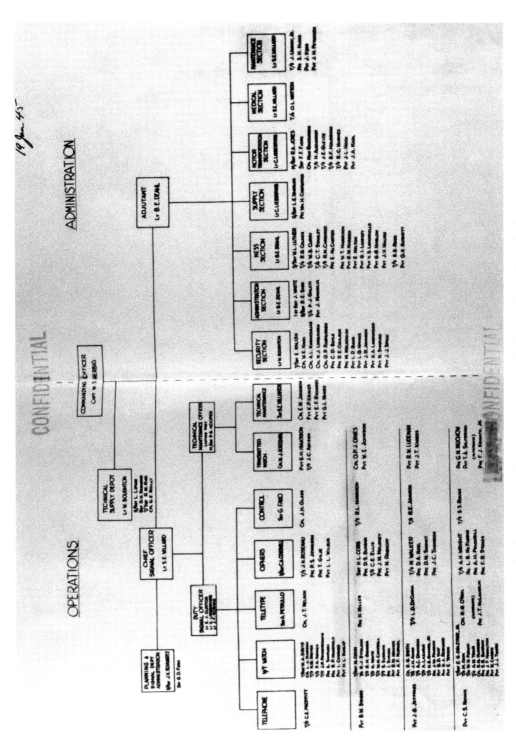

Station VICTOR Operations and Administration chart, January 1945 (NARA M1623 Roll 1 Vol. 1).

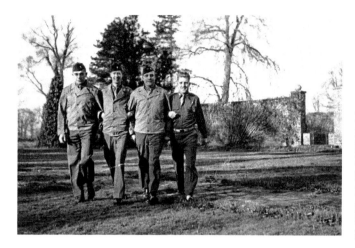

From left to right: Lt John F. Norman, Lt Bruce E. Deahl, Lt Willis E. Boughton and Lt Stanley E.Willard, 1944, in the grounds of Ladye Place, Hurley with brick pillar and ball entrance in the background (Bruce Deahl collection).

Washing down vehicles, with the motor pool area and accommodation huts behind (Bruce Deahl collection).

View of accommodation huts, looking north, taken from the bridge over the ornamental moat in Manor House gardens (courtesy of Joanne Bauguess).

Chapter Six

Infiltration of the Reich

As the campaign in France and the Low Countries came to a close, or stalled, it was realised that there would have to be some reorientation of OSS activity. Up until then the greater part of the personnel and energies had been devoted to assisting the Allied invasion forces by supplying intelligence from behind enemy lines in France. Attention now turned to operations within Germany itself as there was little sign that Hitler was ready to surrender.

In June 1944 OSS Secret Intelligence appointed William J. Casey as its London SI chief with the responsibility of German operations and in the following twelve months, partly under the FAUST plan, he had organised over 100 missions into Nazi Germany involving over 200 agents. The OSS were the only Allied organisation to attempt this penetration due to the extreme hazardous nature of the work. Conditions were far more dangerous than those encountered in occupied France and the British preferred to utilise Ultra intelligence instead than take on this high-risk venture. It was realised that in Germany there would be no friendly reception committees or safe houses with willing volunteers to assist the agents and many forged identity papers were at times an educated guess due to the lack of reliable information. Communication was another problem as the distance back to the home station was further and a suspicious hostile population added to the radio operator's difficulties. Initially agents would have to work using couriers, a slow and dangerous method where other agents would carry messages across the border into Switzerland or cross the front line. Early in 1945, Hilde Meisel an agent known as 'Crocus' was shot in the legs by a German patrol while trying to cross from Austria into Switzerland and to avoid capture she bit into her 'L' pill which contained cyanide, killing herself instantly.

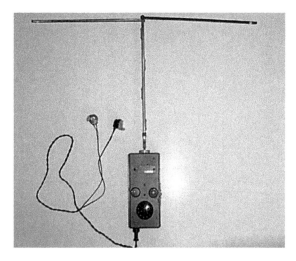

SSTR-502 hand-held transceiver, the 'Joan' of the Joan Eleanor (J/E) ground-to-air VHF communication link. (Courtesy of www.militaryradio. com/spyradio).

Picture still taken from an OSS training film showing 'Joan' in operation. Named after a partner of the inventor, Lt Com. S. H. Simpson who helped establish Station VICTOR.

Mosquito aircraft in US markings, painted black, fitted with the 'Eleanor' set being prepared for a J/E mission, 492nd Bomb Group, Harrington airfield, Northamptonshire, 1945 (courtesy of the Harrington Aviation).

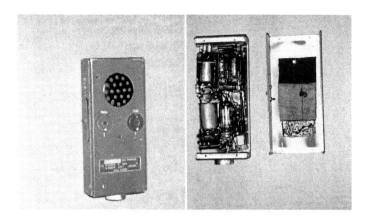

Internal circuit of an SSTR-502. The agent could talk in clear speech to an aircraft thirty miles away and at 35,000 feet without the fear of being DF'd located (courtesy of Dave Kenney).

To improve communications the OSS had developed the Joan Eleanor (J/E) VHF radio system where an agent could talk in clear speech to an aircraft circling 35,000 feet at distances of up to thirty miles. One of the inventors, Lt-Com. Stephen H. Simpson Jnr USNR worked with OSS Communications and had assisted in establishing the R site and T site above Hurley. 'Joan' was the name given to the hand-held transceiver part of the equipment and by using a frequency in the 260 MHz range it was difficult for the Germans to monitor transmissions so no encoding was necessary. It was also virtually impossible to locate the radio operator by direction finding and the verbal report given by the agent could be recorded by the aircraft and listened to once back at the airfield. An ingenious invention that was small in size (6 feet by 3 feet by 1 foot), aiding concealment and mobility which was vital when used by OSS agents operating in urban areas such as Berlin, Essen Leipzig and Munich.

But the function of this equipment required specialist aircraft in order to carry the 'Eleanor' part of the system and the OSS operated several black-painted De Havilland Mosquitoes flying out of RAF Watton and Harrington. The wooden-built Mosquito performed as a fast, high-altitude aircraft which was excellent at avoiding German radar and air defences. Adapted to hold its unusual payload, towards the tail of the aircraft would sit the cramped operator, tuning in the SSTR-6 'Eleanor' ready to pick up, tune in and record the agent's intelligence report. The British SIS used a similar system during the SUSSEX missions called the Ascension referred to by the OSS as 'Klaxon'.

These missions were, however, limited due to the availability of aircraft and agents still had to rely on the more conventional sets such the SSTR-1 suitcase radio. Hurley was now the only OSS communication station left in England and would be needed in future operations. With new equipment now installed at both the receiving and transmitting sites, and the realignment of the masts and antennae, at the beginning of 1945 VICTOR was ready for operations into Germany and Austria.

The men chosen for the first missions deep into the Reich were almost exclusively anti-Nazi expatriates, most were former trade unionists with strong socialist

or communist backgrounds. The OSS had spent time and effort in cultivating relationships with underground labour groups and there were a number of Free Germany movements across the neutral counties of Europe and in Britain itself. From these ranks of dissidents and political refugees came the volunteers who would be trained and parachuted back into their homeland.

But it wasn't only Free Germans that were recruited. The Division of Intelligence Procurement (DIP) was set up within SI and was composed of various international 'desks' with each Allied country recruiting agents through their outposts on the continent. The Belgium desk under the codename ESPINETTE was extremely keen to put agents behind the line following the Ardennes offensive which cost the Allies over 50,000 casualties and ravaged a large part of the Belgian countryside. The Dutch desk went under the codename of MELANIE and, like the Belgians, were selecting and training their countrymen back in London. Other DIP desks included the French, Polish, Czech, Scandinavian and German sections.

While the BACH section worked on all the aspects of an agent's cover story and responsibility for briefing, the training of the Free Germans took place under the name of Operation MILWAUKEE. Communication, organisation, equipment and training were similar to the SUSSEX plan and communications were to be worked back to Station VICTOR. 1st-Lt Robert J. Orwin provided MILWAUKEE with the M signal plan allowing one daily contact between base and the agent who would always use a different call sign on a different frequency at a different time. If the agent wanted further contacts by using a pre-arranged code this could be achieved along with the emergency channel as a backup. One such contact was known as CRAYFISH and others listed during the training period of October 1944 were TUNAFISH and KINGFISH. These names can be observed written on the blackboard behind Lt Herbig in the Signals Office at the R site as part of the daily schedule list. Other contacts on the blackboard can be seen involving the ESPINETTE and MELANIE missions (Belgium and Dutch desks respectively) who were on the continent contacting their underground movements obtaining immediate tactical intelligence and preparing for operations into Germany.

With the success of SUSSEX and PROUST an operation known as Operation EAGLE was planned using Polish military volunteers as observer and radio operator teams parachuting into Germany. These Polish agents would work undercover as forced labourers, hopefully blending in with the thousands of their conscripted countrymen. During February and March 1945 sixteen teams were parachuted into the Reich with what appears to be very little success. Problems with power supply to their radios and not having long enough to establish themselves before being overrun prevented any of the teams from contacting VICTOR.

Up until the middle of February 1945 twelve teams had been dispatched to Germany, including eight by the Labour Desk but due to bad weather further operations had to be cancelled. When the full-moon period began in the middle of

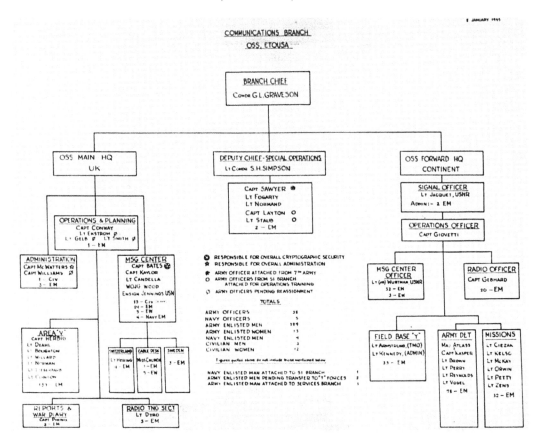

Diagram showing the structure in January 1945 of the Communications Branch OSS ETOUSA January 1945 (NARA M1623 Roll 1 Vol. 1).

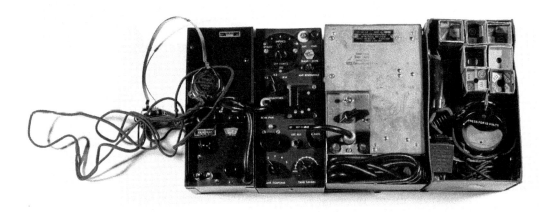

Still widely used as a back-up, the TR-1 W/T set in its component parts which used cyphered Morse code back to Station VICTOR (courtesy Dominique Soulier http://www.plan-sussex-1944.net).

March, teams were dispatched at a faster rate so that by 5 April 1945 thirty teams had been parachuted into Germany.

Allied advances and the fast-changing political situation created a rush of intelligence requests from SHAEF. They were asking for intelligence on Hitler's supposed Redoubt that was being planned deep within the Alps of Southern Germany and Austria so creating a need to cut off the region to prevent entrenchment and escape. There were also rumours of an enemy commando unit known as the 'Werewolves' operating in the Alps, stockpiling masses of weapons and supplies deep in underground tunnels ready to engage in guerrilla warfare. There were still large areas that needed to be covered and, with many agents ready to go, a decision was made for agents to be parachuted in on dark nights without the aid of a moon.

French agent of the BALTO team gets final briefing from BACH representative and representative of French DGER in a London apartment normally used for SO mission briefings, April 1945 (NARA Roll 5 Vol. 12).

French Desk Chief Harold Haviland, foreground, checks equipment and helps with actual packing in basement of Saville Row apartment block. Note W/T set in middle of suitcase wrapped in water-proof covering (NARA Roll 5 Vol. 12).

Over the following two weeks a further fourteen teams were hurriedly parachuted in with some missing their drop zones by many miles.

The DOCTOR Mission

Agents were dropped all over Germany including teams into Berlin but due to geography and distance not all could use VICTOR and as a base station. Some relied on Joan Eleanor while others went through OSS Field Detachments operating close to the front lines.

On 23 March 1945 two agents known as the DOCTOR team from the Belgian desk were parachuted into Kufstein area, fifty miles south of Munich with orders to obtain any evidence of a National Redoubt and to report any rail traffic out of the Reich towards the Italian front. They became one of the most successful teams, managing to organise a resistance movement in the Tyrolean Alps and using it to gain intelligence for the Allies. During forty-five days in enemy territory they sent fifty-two messages back to Hurley, averaging about eighty words a day, and received forty-five messages back at an average of sixty words a day.

DOCTOR consisted of Alfonse Blontrock aka Jean Denis and Jan Smets aka Jan Blocks both of whom had worked together in the Belgian resistance and the SOE. In November 1944 they were sent back to England and, having passed the parachute course, went to Area F at Franklin House, Ruislip to complete their training. The thirty-three-year-old Denis was the radio operator and during the final out-station exercise in Glasgow he was unable to contact VICTOR. Further training was then required delaying the team's deployment until the February/March moon. After an unsatisfactory period of organisational failures between the different departments of the OSS and the air force they failed to get dispatched from Lyon airfield during this period and had to return to London. Suffering further bad weather and being turned back by heavy flak, it took a further four attempts from the airfield at Dijon before the team parachuted in from 700 feet over mountains. Their radio equipment consisted of two SSTR-1 sets with one set of batteries. Station VICTOR had been alerted to listen in on DOCTOR's radio plan known as 'Saturn' and in the early hours of Saturday 24 March 1945 it received from Austria the message, 'The Reich is the arsenal of the enemy through cruelty.' In response came the message from Hurley, 'Congratulations, extremely happy to hear you.'

Three days later Hurley received a message saying they had landed on an unknown plateau in five feet of snow and had been saved by a party of Tyroleans from certain capture and needed food and armaments to continue their work. What they couldn't tell VICTOR at the time was that they had landed some eight kilometres from their intended drop zone and had been approached by what they thought was an enemy ski patrol consisting of three men. While Smets, using his white parachute as camouflage, covered his colleague with a small rifle, Denis had approached this menacing patrol with his agent cover story at the ready. But there

was suddenly no need to use it as the leader of the patrol, Rudolf Steiner identified himself as a friend and immediately told Denis that he must be a parachutist sent by the Allies. By an immense stroke of luck the ski patrol were in fact German Army deserters who had only the previous evening spread the Austrian flag on top of the very mountain where the parachutists had landed. They were hoping to get supplies and assistance and were amazed to hear the low-flying B-24 and thought their message had got through. Being expert skiers and mountaineers they had easily followed the parachutists' tracks, found the containers and discovered the hide out. A short while later the agents found out that their intended drop zone which they missed was being used as a training area for Alpine troops and the cover story given to them would have failed any scrutiny which would have led to their arrests and certain execution.

The next day Station VICTOR received an urgent message from the team asking for equipment to arm twenty men. This equipment was listed as food, binoculars, maps, sleeping bags, weapons, explosives and incendiaries, uniforms of German Mountain troops, a typewriter, medical kits, cigarettes, grenades, sugar, propaganda, receiver radio sets, hand dynamos and a spirit lamp. Within a week they had organised a drop and received all of this except the explosives and incendiaries with a warning message from VICTOR.

You are authorised to equip twenty men for your protection but you must avoid all sabotage which might bring on reprisals. Your mission is above all to do intelligence not sabotage for the moment. When moment for sabotage arrives you will be sent explosives and precise instructions.

DOCTOR protested, replying, 'Security of the members, our prestige and full accomplishment of aims of mission depend on aid sent. We are working for the complete liberation of the Kufstein region.'

A message of thanks for the supplies was received on 8 April but the order never changed.

On 17 April the team were instructed and agreed to receive further teams, VIRGINIA and GEORGIA, by securing a landing ground and providing a friendly reception committee. Further supplies were requested of ration stamps, bedrolls, tents, dry biscuits, chocolate and cigarettes and, 'Movie camera would be most useful.'

On 1 May the team radioed to Station VICTOR that fifty distinguished prisoners were in a concentration camp nearby and 'It is possible we can free them if we receive arms and you authorize this action.' No such authorisation was ever given. What DOCTOR had discovered was a castle used to detain VIP prisoners including Edouard Daladier, the former French Premier who had signed the Munich Pact,

Maurice Gamelin, chief general of the French armed forces at the outbreak of war, Paul Reynaud the French premier and Stalin's son.

The last message from Station VICTOR was on 3 May: 'Await arrival of Allied troops and put yourself and your partisans at the service of G-2 if they want to employ you. Do not expect more parachuting.' The last message from DOCTOR was on 8 May and it read, 'At Zoell have crossed the lines and given tactical intelligence and all documents in my possession to 142nd Regiment have contacted G-2 and am remaining to do a mission for CIC.'

Most of the messages sent by Denis were from farmhouses in the district and by the end of their operation they had four complete radio sets placed in different villages. The power supply was regular and they didn't need to use batteries. The area they operated in was generally anti-Nazi which afforded them quite a bit of assistance and freedom.

Once when Denis was contacting Station VICTOR from a farmhouse in Ellmau he had a lucky escape. The Chief of Staff for Field Marshal Ritter von Greim was in the village looking for emergency lodgings. This Field Marshal had just flown from Berlin having been giving personal orders from Hitler, to rally units of the Luftwaffe for a final assault on the Soviet Army and arrest Himmler who had been denounced as a traitor. At the farmhouse used by Denis there was a loud knocking on the front door from a group of German soldiers. As they entered, running up the stairs to inspect the bedrooms, the owner stood at the top putting his finger to his lips telling them to be quiet as four children were in the room asleep. He managed to usher them into a similar bedroom off to one side which appeared to please them and without seeing the other rooms, they quickly left.

Denis had remained in his room in a bit of a panic, trying to put away the antennae, radio and code books and recorded how pale the owner looked when he walked in telling Denis that they had gone. As the location was difficult with little reception the team moved out of the house, which was a good job as it was this house that the Field Marshal finally used and was still using until when the Allies turned up and arrested him.

During their time in contact with Hurley, DOCTOR submitted intelligence on the following subjects:

1) The location and plans of a heavy mountain infantry and training battalion in Kufstein.
2) Location of war factory and electric power plant in Tyrol.
3) Location or Himmler's special train, new reinforcements of AA in the Valley of the Inn.
4) Location of mountain battery of about 1,000 men.
5) Location or a train load of gasoline.
6) Location of ten AA guns near Kufstein.
7) Location and description of lost remnant of Volksstrum in the Tyrol, numbering 60,000 men; information on two armies on the point of withdrawing from Italy.

'Balto' Agent in 'Strip tease' being prepared prior to journey to airfield, parachute on the floor. Taken at Chateau Brochon, OSS Field base 'Lightning' (NARA Roll 5 Vol. 12).

Agents make final check of papers and money with OSS personnel. (NARA Roll 5 Vol. 12.)

8) Location of the resident Gauleiter Haufer, east Innsbruck.
9) Location of headquarters of the Nazi Wehrwolf organization in the Tyrol.
10) Description of the advance command in Kufstein/Worgl area.
11) Oil depot in Halle area and defences of Inn valley.
12) Location of Fuehrungsstab for the Tyrol.
13) Location or jet plane base at Autobahn near Munich.
14) Location of open-air depot of 2,000 litres of gasoline.
15) Location of prisoner of war camp containing 12,000 prisoners of all nationalities.
16) Location of prisoner of war camp at Schloos Itter where 500 prisoners, including Daladier, Gamelin, Reynaud, the son of Stalin were kept.

Final adjustment to parachute before the 'BALTO' team board a B-24, Dijon airfield, Longvic. (NARA Roll 5 Vol. 12.)

The CHAUFFEUR Mission

Another team from the Belgian desk was CHAUFFEUR who were parachuted into southern Germany near the large Messerschmitt assembly plant at Regensburg. The W/T operator was André Bastian aka André Renaix who was equipped with both Joan-Eleanor and a conventional SSTR-1 radio. During April 1945 he managed nine successful contacts with Station VICTOR and two J/E contacts.

With observer Michel Dehandtschutter aka Albert Lavare they were parachuted in on 31 March, mistakenly five kilometres from their intended drop zone and nearly landing in the River Danube. Having buried their equipment, they later discovered that the instructions for a safe house were wrong, the occupiers having moved away, and while wandering between two villages were stopped and arrested by the Volkssturm. Locked up in a barn, the following day their papers were checked, first by the mayor, then the police from Abensberg, then by the Military Police, followed by the SS. On this occasion their forged paperwork prepared by the BACH section stood up to scrutiny and they were freed. Now having nowhere safe to stay they spent two weeks hiding in the forests surviving off meagre rations that they were supplied with. In trying to contact VICTOR they ran out of battery power and by using a French prisoner of war they had chanced to meet, the battery was recharged at a local garage, allowing them to send their first message through to Hurley.

Operating on plan 'Adhara' on 11 April VICTOR received the following message, 'Arrived safely, are living in forest. Radio difficulties because of lack of current. Have not contacted Regensberg address. Road Abensberg–Regensberg two kilometres before arriving Abbach Mountain is mined. Himmler will be in Chateau at Riedenberg. Bridges at Neustatdt and Kelheim mined.' The contact was then suddenly broken. The battery had discharged again and was later found to be faulty.

VICTOR replied, 'Happy to hear you. Please repeat message after Danube bridges mined. Continue excellent beginning' but nothing was heard.

The second message on 15 April told VICTOR that radio contacts were difficult due to uncharged batteries and asked for batteries of greater capacity to be sent. The message also asked for J/E contact, giving the area.

In case of being totally compromised, the plan was to make their way across the Swiss border and report to the American Consul providing the unusual password, 'Je suis l'idiot de village.' The situation was looking grim, they had lost communication and surviving in the forest was becoming difficult and rather than cross the border the agents decided to act. Locally the POWs worked in a dairy and at great risk to everyone involved allowed the agents to become part of the workforce. Using the dairy's power supply various attempts were made to contact VICTOR but without success. Rather than being idle, by walking into town, the local defences of Regensberg could be observed and knowing they would be checked by the SS, completed a number of trips obtaining vital information.

On 19 April, Renaix tuned into a BBC broadcast and heard details for a J/E contact. That night, having survived the experience of been shot at by a patrol, he found a haystack in an open field near Abensberg. Just after midnight he heard a friendly voice coming from his handheld walkie-talkie J/E radio and a twenty-minute conversation took place where he passed as much information to the receiving aircraft as possible. On returning to the dairy he decided to change the location of the TR-1 set and set the aerial up in the loft. Using the POWs as guards late on 21 April and 22 April, VICTOR was successfully contacted and coded messages passed regarding bridges, flak positions, troop movements, bomb damage, morale and the arrest of two parachutists near Neustadt Bridge. VICTOR in turn passed on instructions from London who wanted the identification of units heading south, defensive positions and railroad movements. Now that communications had been established with VICTOR, detailed messages were sent back over the following nights covering all aspects of military activity in the area and by 28 April they were informed that the Allies were very close by.

Meanwhile in Regensberg, Lavare was having great success having followed the advice of one of the POWs. He contacted two girls who were being forced to work in a German brothel. The girls were French and were willing to help him by talking to their clients on military matters. He advised them on some questions to ask without arousing suspicion and the girls put him in a large closet inside their room with table, chair, pen and paper. For four days he spent several hours making notes on the conversations he heard including from a frequent visitor, a Col Kluger, the grand strategy for the defence of Regensberg.

On seeing the first American soldiers the DOCTOR team identified themselves and were quickly debriefed by senior officers wanting to know the latest intelligence from the area. Several prominent high-ranking Nazis were subsequently arrested

and the passing on of the location and make-up of enemy positions no doubt help save Allied lives.

Success and Failure

With any grand scheme there were successes and failures.

Of the twenty-seven London teams working radio traffic from Germany and Austria back to Station VICTOR only five managed to make successful contact; many could hear Hurley calling on the air but were unable to send their messages through. Of the agent teams, four sets were lost or damaged during parachuting while five sets failed to function. Six teams were dropped so far from their targets they were unable to get into position, two teams were injured on landing, two teams were overrun by Allied forces very quickly, two teams were arrested and one team posted as missing.

Apart from the damaged caused to the radio sets during parachuting, the main complaint from the teams was that the life of the batteries supplied to power the radio sets was far too short for extensive use. Batteries would only last for about ninety minutes before recharging which was just about enough time to make initial contact. This led to the problem of finding a power source to recharge them and due to heavy Allied bombing, power cuts commonly occurred and what power source was found the voltage was at times unsuitable. The PINK LADY team tried to steal car and motorbike batteries hoping to join the batteries together but ended up nearly getting killed by a machine gunner as they plundered abandoned or parked vehicles.

Agents also had problems moving and hiding their equipment due to its bulk and weight, as unlike France they had no reception committees to help with the transportation. By being dropped off course and far away from any safe house, constant bombing and checks on the roads proved extremely hazardous and agents took far longer to get set up. And time is what they didn't have: many teams were overrun by the advancing Allies quite soon after they had been inserted. It was thought on average it took nearly three weeks before a team could organise and establish itself before becoming effective.

Eight teams were given both W/T and J/E equipment and training on the theory that J/E could be used in emergency if W/T failed to get through. Of the nine J/E teams, five were successful, one team and its aircraft was missing (later confirmed killed in action), one team lost their equipment and two teams never made contact. Of the successful teams three operated from Austria.

According to William J. Casey it was generally felt that,

> The J/E was most successful. After getting over initial bugs in the BBC signal
> arrangements and the codes used, and discounting contact attempts which failed

because equipment was destroyed or because of air raids made it impossible to get to the rendezvous, the J/E reached a point where contact could be made virtually every time. It proved to be a gadget of extraordinary flexibility of special value for pathfinder purposes and complementary to a W/T set. The size of the instrument made for much greater security and the ease and speed with which an agent can learn to use it greatly increases the number of operations which can be carried out and the speed on which they can be laid on. Its size, the simplicity of training, the security from direction finding and intercept, the intimate two way transmission, the volume of conversation that can be handled, the possibility of one plane handling multiple contacts in one night – all of these features combine to open up as yet untouched possibilities for large scale intelligence operations.[1]

The End of VICTOR

Following the death of President Roosevelt in April 1945, General Donovan lost a friend and political supporter. At the time Edgar J. Hoover wanted to increase the FBI's remit to include international affairs and political events eventually turned against the OSS. On 20 September 1945 President Truman signed Executive Order 9621 which came into effect on 1 October 1945 so disbanding the organisation. From a letter kept by the family of VICTOR's caretaker Harold Pilbeam, his last day of employment with the OSS was 30 September 1945. SI operations were then taken over by the United States War Office but whether that included VICTOR is unclear. What is known, is that Harold Pilbeam was still living at the Manor House cottage when he died in December 1947, some five years before the Manor House was redeveloped as a private residence. The aerial photograph of Hurley taken in 1950 shows the accommodation area in the Manor grounds still complete and in use with a number of upright poles covering the grounds and gardens. The final payment of £495 for the requisition of the Manor House appears to be made on 14 July 1948.

It was in 1948 that the Grasslands Research Institute became established off Honey Lane and the only building recorded on site was a single-storey T-shaped building erected during the Second World War known as the 'Radar station'. Once taken over this building was occupied by the Ley Agronomy staff and the Grassland Institute administrators until the much larger administration and laboratory buildings were finally completed further down the hill towards the Henley Road. It was later used by the maintenance teams as a workshop for the carpenters, electricians and engineers employed by Grasslands.

After the conflict General Eisenhower credited the intelligence services of shortening the war by several months with the American authorities paying tribute to all the SUSSEX and PROUST agents.

These agents, trained by the British Intelligence Service and the American OSS

Station VICTOR officers, 1945. Rear Manor House steps. From left to right, standing: Lt Bruce E. Deahl, Lt Stanley E. Willard, Capt. William S. Herbig, and Lt Willis E. Boughton. From left to right, seated: Lt John F. Norman, Lt Charles Lieberfarb, Lt Edward J. Clinton, and unknown 'Bailow' (courtesy of the Bruce Deahl collection).

Letter of reference for Harold Pilbeam on the last official day of the existence of the OSS. Signed by the CO, Capt. William S. Herbig (courtesy of Gavin Pilbeam).

OSS MISSION TO GREAT BRITAIN
APO 413, U.S. ARMY
UNIT "V"

30 SEPTEMBER 1945

TO WHOM IT MAY CONCERN:

Mr. Harold Pilbeam, of Hurley Manor House Cottage, Hurley, Berks, was employed as the civilian Gardener for the Manor House property, by this organization from June 1943 through September 30, 1945.

Mr. Pilbeam was at all times a very willing and conscientious worker, and an expert gardener. His conduct and appearance was at all times excellent, and his attitude was that of a very cooperative employee. In addition to his gardeners work, Mr. Pilbeam was very useful about the place handling many of the odd jobs and maintenance details.

I highly recommend Mr. Pilbeam as a gardener, and consider him above the average gardener for ability, cooperation, and a keen interest in his work.

William S. Herbig
William S. Herbig
Captain, Sig., C.
Commanding

Final farewells from Station Victor (courtesy of Joanne Bauguess).

who had been parachuted in order to operate in many different regions north of the river Loire provided the Supreme Allied Commander with accurate intelligence on the enemy order of battle, the location and movement of its Panzer or infantry divisions, the activity of its airfields, the location of its supply, ammunition and petrol dumps including V1 flying bombs and this on a daily basis. This constant flow of information allowed SHAEF to take crucial strategic decisions and to bring bombardment assets on to the right targets.

Between 9 May 1944 and 1 December 1944 VICTOR had managed to handle 10,923 messages comprising of some 785,189 five-letter code groups, all from a wooden hut perched on a hillside above the Thames. The fight to liberate a continent came at a high price. It called for very high professionalism and a total dedication to duty, something which the US servicemen working and living in Hurley demonstrated admirably. They kept their role so secret that none of the local populace ever knew what that they had managed to accomplish. Today, thanks to the records held in the NARA, they can now be remembered and Hurley can be proud to have been the hosts to the OSS and Station VICTOR.

Notes

Chapter Two

1. The Genesis of Station CHARLES by George L. Graveson. K4JI *The OSS CommVets Papers Second Edition*. In his article the Commander makes reference to The Great West Road and The Compleat Angler Hotel both local to Hurley, not Poundon.
2. National Archives Government Property Registers WORK 50/25.
3. 'Sabotage at OSS Station Victor' by Robert Scriven K5WFL, *The OSS CommVets Papers Second Edition*.

Chapter Five

1. Stanley E. Willard W9JAS, *The OSS CommVets Papers Second Edition*. Col Elliot Roosevelt was stationed at Booker commanding the 325th Photographic Wing promoted January 1945.
2. Interview with David Kenney.
3. History on Wheels Museum, Eton Wick.
4. 578 Squadron Memorial and RAF Burn Association.

Chapter Six

1. Casey Final Report, 2 July 1945.

Bibliography and Sources

Bruce, David Kirkpatrick Este, *OSS against the Reich: The World War II Diaries of Colonel David K. E. Bruce* (Ohio: The Kent State University Press, 1991)

Cave Brown, Anthony, *The Secret War Report of the OSS* (New York: Brandt & Brandt, 1976)

Chambers, John Whiteclay, *OSS Training in the National Parks and Service Abroad in World War II* (Washington DC, US National Park Service, 2008)

Fieldhouse, Peter, *The History of Hurley* (2003)

Gould, Jonathan S, *The OSS and the London 'Free Germans' Strange Bedfellows*
(New York: Historical document 2008)

Hurley Parish Council, *The Five Villages of Hurley* (1999)

Howarth, Mary, *Ye Olde Bell at Hurley: Eight Centuries of Hospitality* (Privately published 1991)

Liptak, Eugene, *Office of Strategic Services 1942–45* (Oxford: Osprey Publishing Ltd, 2009)

Lynch, Doria Marie, *The Labor Branch of the Office of Strategic Services, an academic study from a public history perspective.* (Indiana University: 2007)

Ranney, James F, Arthur L. *The OSS CommVets Papers Second Edition* (Kentucky: Ranney, 2002)

Ringlesbach, Dorothy, *OSS: Stories That Can Now Be Told* (Indiana: Authorhouse, 2005)

O'Donnell, Patrick K, *Operatives, Spies and Saboteurs: the Unknown Story of the Men and Women of World Wat II OSS* (New York: Free Press, 1969)

Perquin, Jean-Louis, *The Clandestine Radio Operators* (Paris: Histoire & Collections 2011) www.histoireetcollections.com

Persico, Joseph, *Piercing the Reich* (London: Michael Joseph Ltd, 1979)

Pidgeon, Geoffrey, *The Secret Wireless War, The story of MI6 Communications 1939–1945* (Richmond: Arundle Books, 2008)

Soulier, Dominique, *The Sussex Plan, Secret war in Occupied France 1939–1945* (Paris: Histoire & Collections, 2013) www.histoireetcollections.com

Summersby Morgan, Kay, *Past Forgetting* (London Collins, 1977)

The War Report of the Office of Strategic Services (Kermit Roosevelt, 1948)

The U.S. National Archives and Records Administration (NARA) College Park Maryland. *Record Group 226 History of OSS in London History of the London Office M1623 History of the Office of Strategic Services in London, 1941–45*

This series contains files which document the activities of the Office of Strategic Services (OSS) in London. The following OSS branches maintained offices in London: the Communications Branch, the Field Photographic Branch, the Morale Operations Branch, the Research and Analysis Branch, the Secret Intelligence Branch, and the Special Operations Branch. In addition, the following OSS offices also maintained staff in London: Medical Services, Research and Development, Security, Services, and Special Funds. Finally, this series also contains files relating to maritime units, the commanding officer, and Counter Espionage (X-2) War Diaries. Series topics include Station Charles, Station Victor, continental operations, technical operations, staff biographies, psychological warfare, topography, civil affairs, the SUSSEX Mission, the PROUST Mission, field detachments, planning, Jedburgh Team operations, air operations, training, and supplies.

Glossary

Area A:	SUSSEX training centre at St Albans also known as Glenalmond or TS-7
Area B:	PROUST training centre Drungewick Manor, near Horsham Surrey also known as 'Freehold'
AR-77:	Radio Receiver
AT-3:	Radio Transmitter
BCRA:	Free French Secret Service
BRISSEX:	British SIS part of Operation SUSSEX
Broadway:	British Secret Intelligence Service
CIA:	Central Intelligence Agency
D Day:	Invasion of Normandy 06/06/1944
DGER.	Directorate General of Studies and Research. French Intelligence Service following BCRA
DZ:	Drop Zone
ESPINETTE:	SI/OSS mission to Belgium
ETO:	European Theatre of Operations
ETOUSA:	European Theatre of Operations United States Army
FUSAG:	Fictitious First US Army Group, part of Operation Quicksilver that duped Hitler to believe invasion would occur across the Pas de Calais
G-2:	Intelligence section within an Army Division or higher establishment
HRO:	Radio Receiver
J/E.	Joan Eleanor. American ground to air radio
Klaxon:	British ground to air radio used by SUSSEX teams, sometimes referred to as the S phone.
MI5:	British Military Intelligence Domestic Affairs
MI6:	British Military Intelligence Foreign Affairs
Mark 7:	Clandestine radio set could be hidden in a suitcase
MELANIE:	SI mission to Holland
MILWAUKEE:	SI training school for Labour Division agents, known as Area M.

MOW: Ministry of Works
NARA: National Archives and Records Administration. US National
 Archives Maryland.
OG: Operational Group OSS
OS: Special Operations
OSS: Office of Strategic Services.
OSSEX: OSS SI part of Operation SUSSEX within American zone
Overlord: D-Day Operation
Pathfinder: Initial reconnaissance awaiting SUSSEX teams
PROUST: Operation quickly implemented to follow & reinforce Operation
 SUSSEX.
S2: Staff Officer in charge of Military Intelligence
SC: US Army Signal Corps
SCR-193: Vehicle mounted transmitter receiver used by OSS mobile units SO,
 X-2 & later mobile OSSEX teams
SF: Special Forces
SHAEF: Supreme Headquarters Allied Expeditionary Force
SIGTOT: Secure teletype system linking Hurley to London
SIS: Secret Intelligence Services (British)
SO: Special Operations of OSS
SOE: Special Operations Executive (British)
SSTR-1: US clandestine radio set fitted inside suitcase, various versions.
STS. Special Training School
S-phone: British developmental ground air radio telephone used by agents to
 communicate with friendly aircraft
SUSSEX: Covert operation to identify and locate tactical & strategic military
 targets (*Le Plan Sussex*)
USAAF: United States Army Air Force
USNR: United States Navy Reserve
W/T: Wireless telegraph
X-2: OSS Counter Espionage

Index